# 50 GEMS OF
# South Devon

GARY HOLPIN

AMBERLEY

First published 2020

Amberley Publishing
The Hill, Stroud
Gloucestershire, GL5 4EP

www.amberley-books.com

British Library Cataloguing in Publication Data.
A catalogue record for this book is available from the British Library.

ISBN 978 1 4456 9654 6 (paperback)
ISBN 978 1 4456 9655 3 (ebook)

Typesetting by Aura Technology and Software Services, India.
Printed in Great Britain.

# Contents

Map 4
Introduction 6

South East Devon 7
1. Blackbury Camp 7
2. Ottery Tar Barrels 9
3. The Exe Estuary Cycle Trail 10
4. Weston Mouth Beach 12
5. The South West Coast Path 13
6. A Walk Through the Seaton Undercliff 15
7. Regency Sidmouth 16
8. The River Exe Café 18
9. The View from Fire Beacon Hill 19
10. Beer Village 21
11. View from Roundball Hill, Honiton 23
12. Exeter's Roman Walls 25
13. The Sea Stacks of Ladram Bay 27

South West Devon 29
14. Brixham Harbour 29
15. The River Erme Estuary 31
16. Salcombe 33
17. The Daymark Tower 35
18. Cockington 37
19. Dartmouth Castle 39
20. The Stoke Gabriel Yew 40
21. Teignmouth Pier 42
22. The Great Western Railway 44
23. The Spanish Barn 46
24. Elberry Cove 48
25. Slapton Sands 50

26. Plymouth Hoe 51
27. Burgh Island 53
28. Plymouth National Firework Championship 55
29. A Walk Around Bolt Head 56
30. Start Point 58
31. Totnes 60
32. Kents Cavern 62
33. Boringdon Hall 64

Dartmoor 66
34. Scorhill Stone Circle 66
35. Brentor Church 68
36. Black-a-Tor Copse 70
37. Meldon Reservoir 72
38. Lydford Gorge 74
39. Hound Tor 76
40. Emsworthy Mire 78
41. Fingle Bridge 79
42. Venford Falls 81
43. The View from Bench Tor 82
44. Leather Tor and Sharpitor 83
45. Widecombe-in-the-Moor 85
46. Foggintor Quarry 87
47. The Warren House Inn 89

Inland Devon 91
48. The Grand Western Canal 91
49. Coldharbour Mill 93
50. The View from Culmstock Beacon 94

About the Author 96

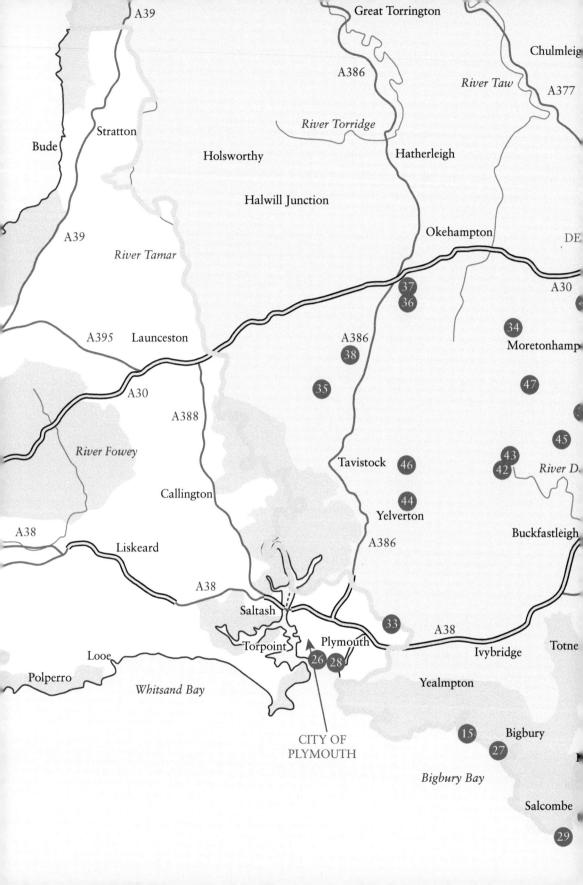

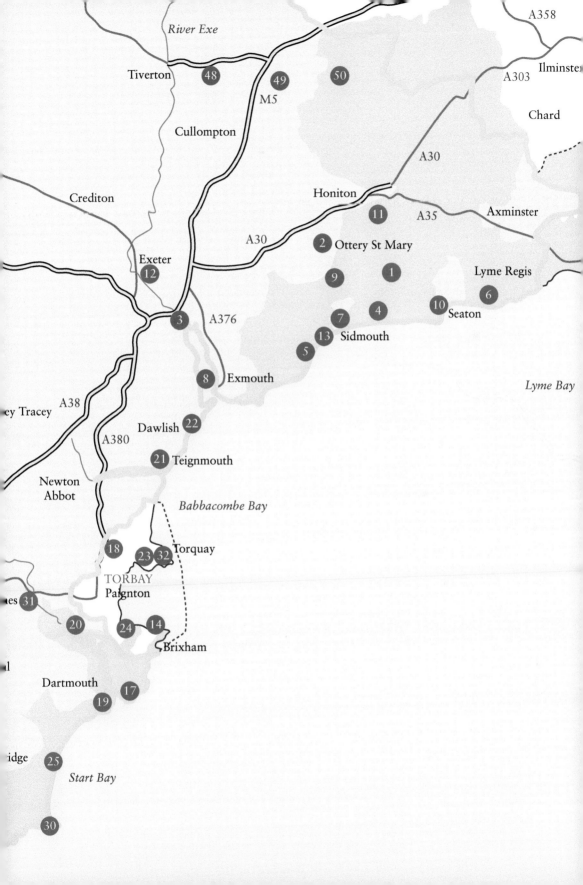

# Introduction

For many years, Devon for me was just a place of childhood holiday memories; of buckets and spades, and long hot summers (in my memory at least!); of ice creams, sandy beaches and screeching seagulls. However, after many years living in the South East, I have been lucky enough to call Devon my home since 2003. Since moving here, my Devon horizons have slowly started to open up. Firstly, I explored the coast by walking the spectacular South West Coast Path, then since becoming a landscape photographer I have slowly explored more and more inland parts of this wonderful county.

*50 Gems of South Devon* isn't a comprehensive travel guide, but instead is a carefully selected assortment of some of the amazing places that I have discovered while exploring South Devon, and is aimed at giving you just a flavour of this wonderful place that I call home. It's no coincidence that as a landscape photographer, most of the locations are extremely scenic and photogenic. Although some may be well known and easy to get to, others are definitely off the beaten track and will take more effort to find. As a professional photographer, I hope you enjoy the photography, all of which was taken by me during my travels, and hopefully I have succeeded in capturing the amazing beauty of South Devon. If you do enjoy the photography, you can see more of my work at www.garyholpin.co.uk.

Geographically, *50 Gems of South Devon* covers the southern half of the county, roughly south of a line between Okehampton and Tiverton, and the book is split into invented geographical areas simply for ease of navigation. These are referred to as 'South East Devon' (covering the East Devon coast from the River Exe to the Dorset border, and as far inland as Honiton); 'South West Devon' (covering the coast from Dawlish Warren to Plymouth and the border with Cornwall, and as far inland as the southern edge of Dartmoor); 'Dartmoor' (which is fairly self-explanatory!); and 'Inland Devon', which covers anywhere north of those regions.

In this book we explore the wild open moorlands of Dartmoor, with rugged tors, ancient stunted oak woodlands and hidden waterfalls; one of the most beautiful stretches of coastline in the UK along the South Devon Coast and the South Hams Area of Outstanding Natural Beauty, the lovely rolling East Devon countryside and the amazing Jurassic coast; as well as some hidden gems of inland Devon. Along the way, we explore ancient hill forts and castles, find remote and beautiful waterfalls, wander deep into the moors to find stunted oak forests, and admire some stunning Devon views.

Despite sixteen years in Devon, I feel I've still only scratched the surface of what this amazing county has to offer, but I hope that the locations covered in the following pages will help to kickstart your exploration of, and love for, the place that I'm lucky enough to call home.

What's your gem of South Devon? If I've not included it, please drop me an email at 50Gems@garyholpin.co.uk so that I can add it to my list of places to explore.

# South East Devon

## 1. Blackbury Camp

For a bit of peace and tranquillity with just the sounds of nature for company, a visit to the beautiful and historic Blackbury Camp is a must. Midway between Sidmouth and Seaton and a couple of miles inland, Blackbury Camp is owned and cared for by English Heritage, and is one of many Iron Age hill forts scattered across the East Devon countryside.

The fort consists of a large oval grassy area, around 200 metres long and 100 metres wide, scattered with mature trees and surrounded by high earth banks. The ditches have silted up over time, so the banks would originally have been much

A carpet of spring bluebells beneath the trees at Blackbury Camp.

more imposing at over 5 metres high, making the fort easier to defend against invaders. These days it's a quiet and calm place to sit and listen to nature, and has the feeling of being a very ancient place. It's especially beautiful in the spring, when the whole area is carpeted with native bluebells, but if you do visit then, please try and keep to the paths, as bluebells are easily killed by being trodden on.

Finds from an archaeological dig in the 1950s suggests that the fort dates from the middle part of the Iron Age, which was a period when iron slowly began to replace bronze for tools and weapons, and covered roughly the period from 800 BC to the arrival of the Romans in AD 100. It's likely that like most Iron Age hill forts, Blackbury Camp was a defended homestead for a small community, with the inner enclosure being where the people lived and the outer enclosures for their livestock.

The people who originally lived at Blackbury Camp were the Dumnonii, the ancient inhabitants of Devon and Cornwall. Archaeological finds have included local pottery used for cooking, as well as evidence of wooden buildings and metal working, indicating the fort once housed a busy community. At the time, the area around the fort was likely to have been a patchwork of woodland, open grazing areas and small arable plots – not hugely different to the landscape today!

The original entrance to the enclosure was in the south and was an imposing construction, with a channel lined by wooden posts and large wooden gates with a walkway above. This ensured that invited guests would be impressed by the fort, and unwelcome ones would have to enter through a narrow channel where they could be more easily attacked. The defensive purpose of the fort was clearly demonstrated by finds during the 1950s excavation, which included over a thousand sling stones, mainly around the area of the southern entrance.

Blackbury Camp is signposted off the Seaton Road between the A375 at Putts Corner and the A3052 between Sidmouth and Beer.

A footpath now snakes along the top of the ancient defensive banks.

# 2. Ottery Tar Barrels

If there's one event that truly has to be seen to be believed, it's the amazing burning tar barrels of Ottery St Mary. Every year, on the night of 5 November (unless it's a Sunday) there is the amazing sight of burning tar barrels being carried through crowds of people crammed into the narrow streets of the town. It's a tradition that dates back hundreds of years, and it still amazes me every time I go.

The custom of burning tarred barrels is not unique in Britain; there are several towns and villages that roll burning barrels through the streets to mark Guy Fawkes night. However, the East Devon folk of Ottery St Mary are made of sterner stuff and insist on running through the streets of their town carrying their burning barrels on their backs.

The reason behind the tradition of burning tar barrels is lost in history, but suggested reasons include that it was a pagan ritual to clean the streets of evil spirits, a method of fumigating houses, or as a warning of the approaching Spanish Armada. The most likely explanation, however, is that it's simply a celebration of the infamous gunpowder plot of 1605, when Guy Fawkes led a group of Catholic conspirators in a failed attempt to blow up the Houses of Parliament.

Barrels are sponsored by local pubs and are soaked in tar in the lead up to the event, to make them nicely flammable. During the afternoon of the event, the streets of Ottery are closed to traffic and slowly fill up with expectant crowds, and then one by one, the

Getting ready to carry a burning barrel through the streets.

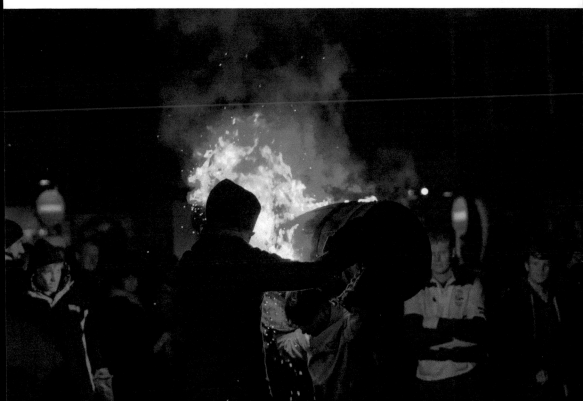

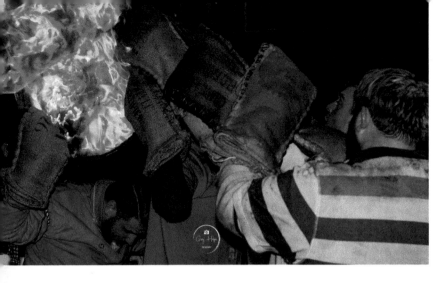

Outrunners help to clear a space through the crowds.

barrels are lit and then a local Ottery resident (chosen from generations of the same families) will raise the burning barrel onto their shoulders (protected as much as is possible by thick coats and oven gloves!). With marshals running ahead to try and clear a path through the crowds, they then run with the barrel through the crowded streets, with flames and smoke erupting into the night air. In the late afternoon, the barrels are smaller and carried by local teenagers; then the size of the barrels slowly increase through the evening as local women and men take their turn, until midnight when the biggest barrel, weighing in at an enormous 30 kg, is lit and carried through the crowded streets.

It's a once a year spectacle, and really has to be seen to be believed. However, if you don't like flames, or crowds, then it's definitely not for you! The town is closed off for the event, but car parks are provided on the outskirts of town and public transport is also provided.

# 3. The Exe Estuary Cycle Trail

For anyone who enjoys a bit of cycling, the Exe Estuary cycle trail (part of National Route 2) is a fantastic way to explore the lower reaches of the River Exe and the many small riverside villages along its length. The trail is an almost traffic free, fairly level, 26-mile route that starts at Dawlish, travels up the western side of the Exe (via Cockwood and Starcross) to Exeter Quay, before returning down the eastern side via Topsham and Lympstone, to end on the seafront at Exmouth.

Although a round trip of the whole trail might be too much for all but the keenest cyclists, it's easy to split a visit into more manageable sections due to local train services with multiple stops down both sides of the estuary. There are also seasonal ferries that cross the river from Exmouth to Starcross, and a smaller ferry at Topsham.

There are a number of fine hostelries along the trail to stop off for refreshments, including the canal-side Double Locks Hotel just south of Exeter, and further south at Exminster (on the western side of the river) the Turf Hotel with a fabulous riverside beer garden. On the eastern side of the river the Lighter Inn at Topsham is right on the trail and worth a visit, and The Swan Inn at Lympstone is also right on the trail (and conveniently around halfway between Exeter and Exmouth).

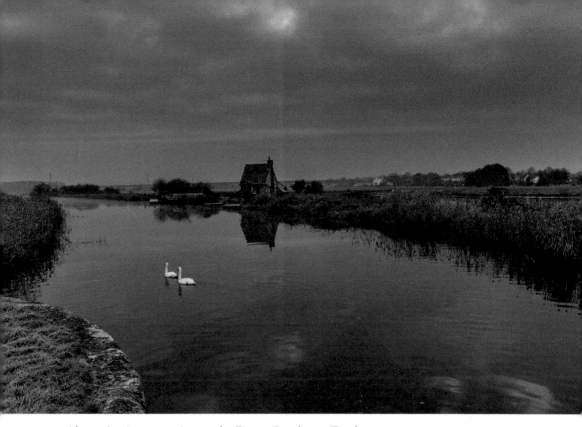

*Above*: A winter morning on the Exeter Canal near Topsham.

*Below*: Sunset over Exeter Quay.

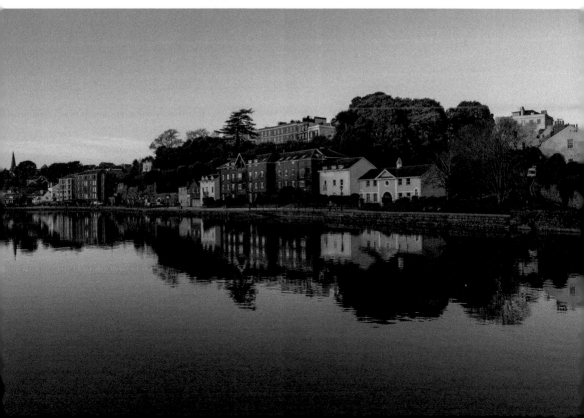

There is plenty to see and enjoy along the trail, especially for nature lovers as the estuary itself is of international importance for wintering wildfowl and a Site of Special Scientific Interest for its flora and fauna. There are RSPB reserves at both Dawlish Warren and Topsham that are great for a bit of bird spotting.

It's also worth stopping off for a look around the historic Exeter Quay, one of the most scenic parts of the city, next to the River Exe and the Exeter Ship Canal. First used as a port in prehistoric times, ships navigated the river until it became silted up and finally impassable in the fourteenth century. In 1566 a canal was completed to once again allow access to shipping, and this was used extensively until the railways reached the South West in the early nineteenth century and the demand for shipping declined.

Exeter itself is an ancient city, with evidence of settlement stretching back as early as 250 BC, although the modern settlement began as the Roman settlement of Isca Dumnoniorum (Isca for short), which grew up around a Roman fort established in AD 55.

You can, of course, also walk the Exe Estuary Trail, but if you do, please watch out for bikes!

# 4. Weston Mouth Beach

Devon beaches are normally busy places, especially in the summer months when thousands of visitors arrive to enjoy the beauty of the county's many beaches. However, Weston Mouth Beach, midway between Branscombe and Sidmouth, is an exception to this rule, since it is at the bottom of a steep valley and almost a mile from the nearest roads at Weston and Dunscombe.

Weston Mouth is a pretty beach, backed by iconic red Devon sandstone cliffs, and like most East Devon beaches, mainly of shingle. The lack of either road access or facilities means that the beach is quiet most of the year, especially out of season when

*Below left*: Driftwood on a moody winter's day on Weston Mouth Beach.

*Below right*: A rainbow at sunset on Weston Mouth Beach.

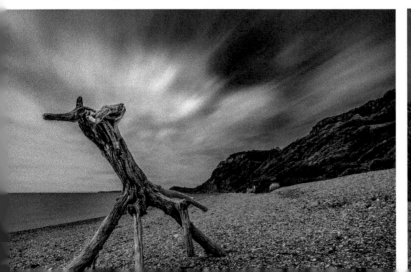

it's easy to have the whole beach to yourself. It's a fantastic place to sit and listen to the sounds of the waves rolling onto the shingle, with seabirds screeching above. Although it's known as a nudist beach, I've never seen it used as such, and especially in the chilly winter months, I think you would need to be brave to try!

Just above the beach, halfway up Dunscombe Cliff (to the west), is the National Trust owned Weston Plats. Although now mainly reclaimed by nature, Weston Plats were clifftop plots farmed by locals to generate a cash income in the nineteenth century. Thanks to its sheltered aspect, it had a favourable microclimate that was perfect for producing early crops of flowers and vegetables, which were harvested, and carried by donkeys back up the valley. At one time early potatoes from Weston Plats rivalled those from Jersey. Eventually tourism started to take over in importance, and by the 1960s the Plats were abandoned and quickly reclaimed by nature.

If you want to find some peace and quiet away from the summer crowds, Weston Mouth is definitely a place worth searching out. The best way to reach it is to park in the small National Trust car park at Weston and follow the path downhill from the car park, turning right at the bottom onto the Coast Path, which takes you down to the beach. It's an easy walk down, but be aware that it's a steep and quite tiring return trip!

# 5. The South West Coast Path

Although it's a gem of the entire South West, rather than just South Devon, since my experience of walking the South West Coast Path was what inspired me to become a photographer, it was essential that it just had to feature in this book. If, like me, you want to explore the towns, villages and coastal beauty of South Devon, there is no better way than a walk along all 202 miles of the Coast Path, which covers the entire South Devon coast from Plymouth in the south to Seaton in the east.

The South West Coast Path is a continuously waymarked and well-maintained footpath that travels around the whole of the south-west peninsular from Minehead in the north to Poole harbour in the south. It was first designated as a National Trail in 1978, and as it travels through five Areas of Outstanding Natural Beauty, one National Park, and two UNESCO World Heritage sites, you could say it has quite

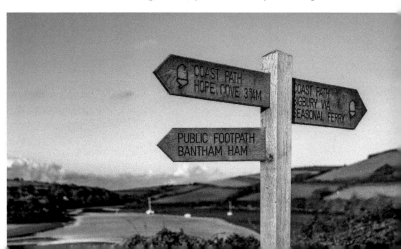

The iconic acorn symbol marks the South West Coast Path National Trail at Bantham. (Image by Gary Holpin, used with kind permission of Coast & Country Cottages)

a lot going for it! Perhaps unsurprisingly it's internationally regarded as one of the finest long-distance walking trails in the world.

Although a visit to any south-west coastal town, clifftop or beach will involve walking a little bit of the Coast Path (even if you didn't realise it!), walking all of it is not an insignificant challenge. As well as being 630 miles from end to end, thanks to its hundreds of hills and river valleys, walking all of it involves 115,000 feet of climb – the equivalent of climbing Everest almost four times, or Britain's highest mountain, Ben Nevis, twenty-six times!

Although it only became a National Trail in 1978, many of the clifftop paths from which the Coast Path is formed have existed for centuries, created by generations of smugglers and those whose job it was to try and catch them. By the early eighteenth century it was estimated that more than half of the spirits being drunk in Britain were being smuggled in, with much of it being brought in around the coast of the South West, which was perfect for smuggling with hundreds of miles of remote coastline and sparse authority. By the early nineteenth century the government were so desperate for money to fund the ongoing wars with France that they decided to put a stop to smuggling, and in 1822 the National Coast Guard Service was born. The Coast Guard Service was essentially a human cordon thrown around the entire coast of the UK, and in Devon a guard was posted every half a mile. As part of their patrols to see into every remote cove, a network of clifftop paths was formed, and it was this network that 150 years later would be joined up to form the South West Coast Path.

If you do decide to tackle any of the Coast Path, a charity called the South West Coast Path Association provides fantastic information and resources, as well as raising funds to help maintain and improve the it (see www.southwestcoastpath.org.uk/).

The Coast Path around Beer Head, bathed in the glow of a winter sunrise.

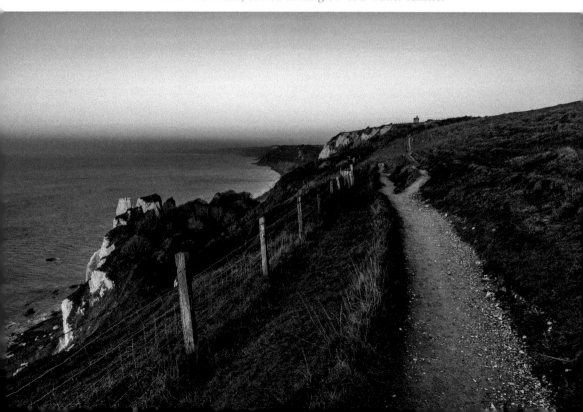

# 6. A Walk Through the Seaton Undercliff

If you want to experience real wilderness then you just have to experience a walk through the Seaton Undercliff. Most of the 7 miles of rugged woodland footpath (part of the South West Coast Path) from Seaton, over the Dorset border to Lyme Regis, passes through an area called 'the Undercliff' – one of the settings for *The French Lieutenant's Woman*, the 1969 novel by John Fowles. The Undercliff is one of the largest active coastal landslide systems in Western Europe, and a place where nature and time has created one of the last remaining wildernesses in Southern England.

The Undercliff was formed by a series of major landslips during the late eighteenth and early nineteenth centuries, including The Great Slip, a cataclysmic event on Christmas Day 1839, when 15 acres of arable land slipped from the cliffs to form a chasm 60 metres deep and half a mile long. At the time the spectacle drew thousands of curious visitors including Queen Victoria, who came to view it from her yacht in the channel.

Although much of the landslip area was originally open pasture, grazed by rabbits and sheep, once sheep farming ceased the rough landscape gradually became overgrown and is now a wonderful rough, wild and rugged landscape. Although the whole area is now a National Nature Reserve, one part of the landslip called Goat Island is particularly important for wildlife, as it has seen no modern cultivation or fertiliser since the day it fell from the clifftop 150 years ago. This makes it a fantastic habitat for native species. including a number of rare orchids.

The Undercliff is well worth a visit for its natural wild beauty, and to get to it, simply follow signs to the Coast Path from either Seaton or Lyme Regis. However, be aware that it is a rugged and difficult terrain, and once you've started walking it, there is no way out until you get all the way to the other end!

*Below left*: A glimpse of a hidden beach through the trees of the Undercliff.

*Below right*: An early purple orchid on the Undercliff at Goat Island.

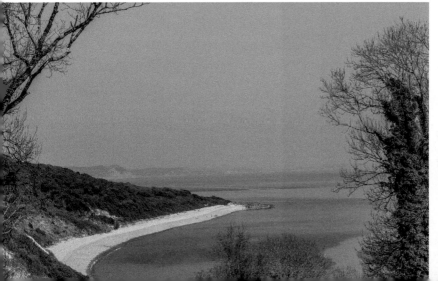

# 7. Regency Sidmouth

Around halfway between Exmouth and Seaton, on the Jurassic Coast, is the small seaside town of Sidmouth. Nestled in the valley of the River Sid, surrounded by the rolling countryside of the East Devon Area of Outstanding Natural Beauty and bookended by iconic red Devon sandstone cliffs, Sidmouth is a true gem of South Devon. A visit to the town is a little like going back to simpler times (definitely in a good way). It has a traditional promenade, which is lined with striped deck chairs in the summer months and overlooked by a row of traditional seaside hotels, many of which retain their Regency era charm.

Unsurprisingly, the mild south coast of Devon has been an attractive place to live since ancient times. Excavations at Peak Hill (or High Peak), which rises steeply to the west of the town, have previously found evidence of an Iron Age hill fort, as well as evidence of earlier Dark Ages occupation and use by the Romans. Like many Devon coastal settlements, Sidmouth was a small fishing village at the time of the Domesday Book of 1086, with fishermen catching abundant herring from the waters of Lyme Bay. It largely remained a fishing village until the fashion for seaside holidays grew in the eighteenth and nineteenth centuries when it became popular with tourists, a trend which continued with the arrival of the railways in 1874.

In the 1950s, the then Poet Laureate John Betjeman described Sidmouth as 'a town caught in a timeless charm', and despite the inevitable modern world intervening over the decades, the town retains much of this charm, with narrow streets lined with

A stunning winter sunrise over Jacob's Ladder.

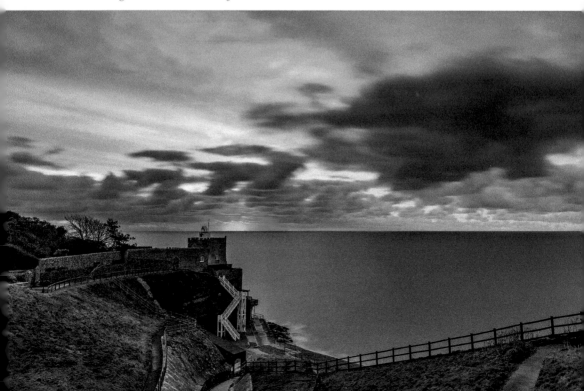

independent shops, fine gardens of semi-tropical plants, thriving in this sheltered location; and fine sandy beaches which are exposed at low tide.

For an exhilarating walk, you can follow the Coast Path and either head west, for panoramic views from Peak Hill, or east to Salcombe Hill, which is covered in woodland filled with bluebells in the spring. Whichever way you choose, there are fine views over the town nestled in the valley below, and fantastic views along the beautiful Jurassic Coast, and on a fine day you can even see Portland, 50 miles to the east.

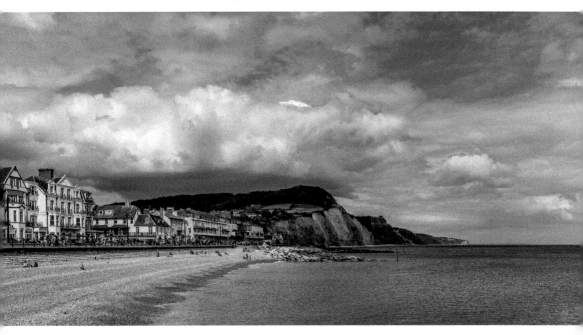

*Above*: A beautiful summer's day on Sidmouth Beach.

*Below*: A spring dawn breaks over Sidmouth seafront.

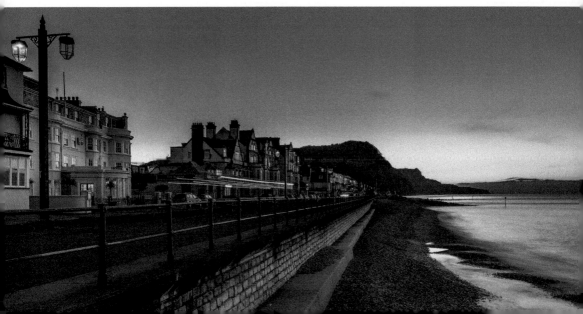

# 8.  The River Exe Café

If you fancy sampling some of Devon's finest fresh produce, there can't be many more unique places to do so than at a restaurant moored in the middle of a river! Since 2011, the River Exe Café has been serving up tasty local food with a chilled-out atmosphere from its position moored on the River Exe, not far from Starcross. Constructed of two flatbed barges, a large wooden shed and 1.7 km of decking, the café has space for 100 customers, both outside and under cover, and operates from April to September.

Being in the middle of the river, the café can only be accessed by water taxi from nearby Exmouth, and on a sunny day those with their own boat can also just tie up and enjoy a drink at the bar, with fantastic views over the Exe Estuary and nearby coastline.

The River Exe on which the café sits is almost 60 miles long, with its source at Simonsbath on Exmoor, only 5 miles from the North Somerset coast, before flowing through the heart of Devon, meeting the English Channel at Exmouth. Its name is derived from the old English 'Iska', meaning 'water' or 'abounding in fish', and it gives its name to many settlements along its length, including Exford, Exminster, Exmouth and, of course, Devon's county town of Exeter.

The river has played an important role in the history of the many communities along its length. The Romans arrived at the Exe around AD 50 and made Exeter their

Sunset from the River Exe Café.

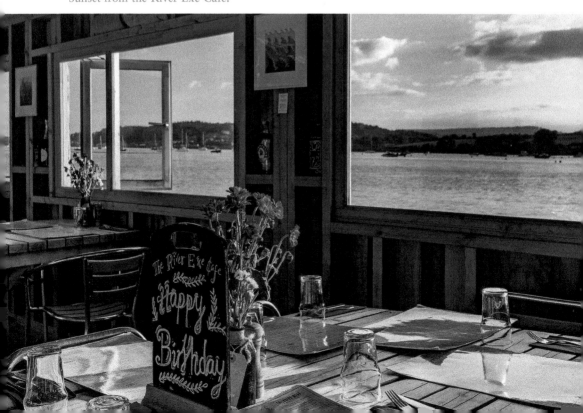

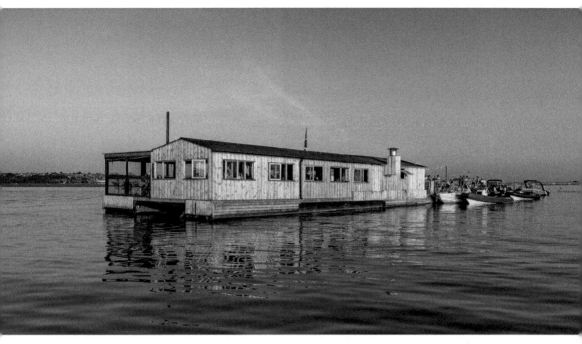

The café bathed in the golden light of a summer sunset, viewed from the water taxi.

main settlement, as it marked the lowest point on the river where it could be easily crossed. Further upstream at Tiverton, the waters of the Exe powered the woollen mills that brought about the rapid growth and prosperity of the town in the sixteenth and seventeenth centuries.

Unsurprisingly, the Exe Café is a pretty popular destination, so if you want to visit you will need to make sure that you book well in advance and remember to book your water taxi at the same time!

# 9. The View from Fire Beacon Hill

One of the best places to admire the beautiful rolling East Devon countryside has to be the spectacular panoramic views from the top of Fire Beacon Hill, a Local Nature Reserve a few miles inland from Sidmouth.

As its name suggests, the hill was once the site of one of a chain of bonfires that were lit on prominent hilltops as an early form of communication. One of the most famous uses would undoubtedly have been to send news to Elizabethan London of the first sighting of the ships of the Spanish Armada in the Channel in 1588. The same chain of fires was later used to celebrate Sir Francis Drake's victory over the Spanish, and similar hilltop fires have been used throughout history to mark other

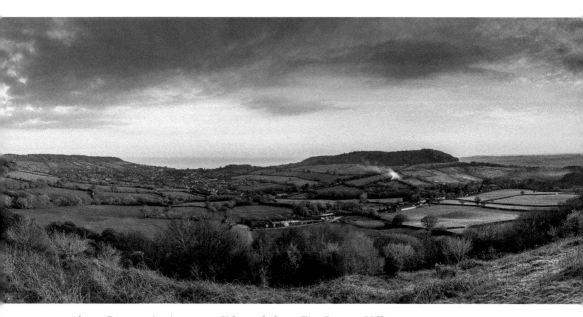

*Above*: Panoramic views over Sidmouth from Fire Beacon Hill.

*Below*: Fog over the East Devon countryside from Fire Beacon Hill.

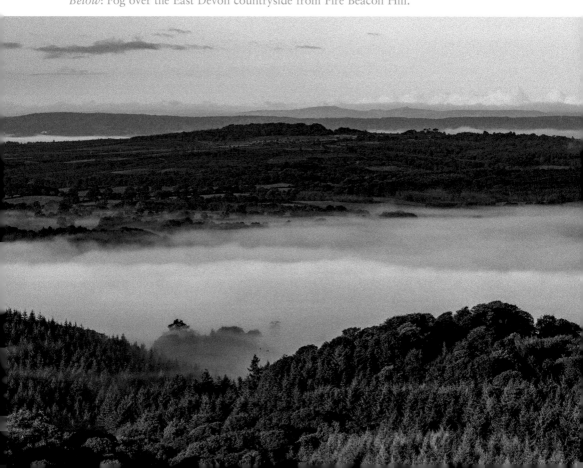

national celebrations. In the nineteenth century the remains of the ancient beacon were still visible, but all traces have now sadly gone.

Fire Beacon Hill sits at the end of the East Hill escarpment, 225 metres above sea level, and provides stunning views over Sidmouth and Lyme Bay – west over the rolling countryside towards Otterton and Ladram Bay, and east towards Salcombe Hill. On a clear day you may even be able to see all the way to Portland, almost 50 miles east of Sidmouth, and down the south coast of Devon towards Brixham.

Such a prominent feature in the landscape will have attracted people throughout history, and there are records of prehistoric burial mounds being found in the area. The hill has been attracting people for centuries just for the views, with John Taylor Coleridge (the brother of the poet Samuel Taylor Coleridge) writing that 'There, on the short green turf we often rested and enjoyed a view which for beauty, variety and extent is not easily to be surpassed. Down deep on the left lay Sidmouth and the blue sea'.

Fire Beacon Hill is a Nature Reserve and an area of lowland heath, which is found on poor acidic soils and is home to a range of native shrubs such as heather, gorse and bilberry. The UK has lost 84 per cent of its lowland heath, an important habitat for a range of specialised native plants and animals, including reptiles such as the adder, grass snake and slowworm, all of which have been found at Fire Beacon Hill.

The top of Fire Beacon Hill is at grid reference SY 11229 90802. To get there, follow the signed footpath to Fire Beacon Nature Reserve from Fire Beacon Lane, just off the A3052 road, west of Sidmouth.

# 10. Beer Village

As well as a place with a great name, Beer is also an unspoiled picture-postcard seaside village nestled around a small pebble cove on the beautiful Jurassic Coast.

Although the name has no association with the drink (its name actually comes from 'Bearu', the old English name for 'woodland'), for centuries the village was a centre for the illicit trade in booze of the smuggled variety. Historically the main livelihood for many in the village was fishing, and Beer fishermen were renowned for their seafaring skills. However, in the late eighteenth and early nineteenth century some used these skills to supplement their income with a bit of smuggling. Their contraband generally consisted of casks of brandy and rum, as well as tea, tobacco and silk. The goods were brought in from the Channel Islands and the north coast of France, before being hidden in remote locations in the local area such as nearby Beer Caves. The men of Beer were so good at it that writers of the late eighteenth century described them as the 'kings of smugglers'.

One of the most famous local smugglers was Jack Rattenbury. Born in Beer in 1778, he went on to lead a gang of smugglers, becoming one of the most notorious smugglers in the country and the bane of local customs men whom he always used to manage to escape.

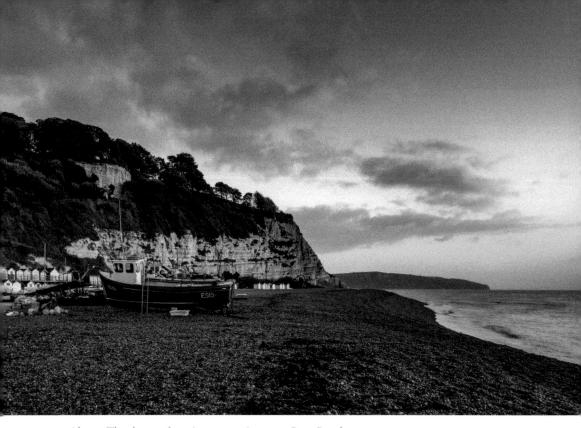

*Above*: The dawn of a winter morning over Beer Beach.

*Below*: Colourful fishing boats waiting for high tide.

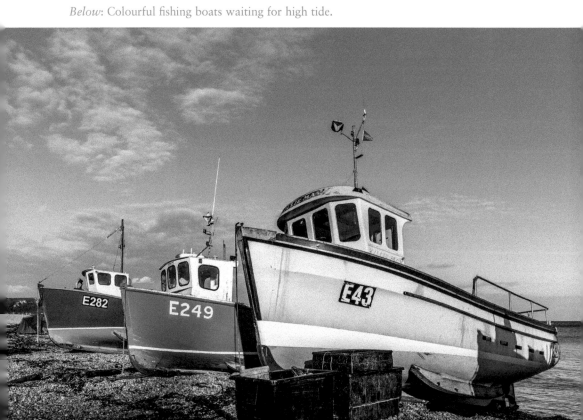

Golden morning light over the landing stage.

Beer is a much less lawless place today, and is a popular tourist destination for its pretty high street and sheltered pebble beach surrounded by high chalk cliffs. The beach is still a working beach, a place where holidaymakers, ice-cream stalls and deckchairs nestle with crab pots and the winch cables of colourful fishing boats, which sit hauled up on the beach waiting for the next high tide. You can buy some of the days catch from a small wet fish at the top of the beach, literally metres from where it was brought ashore.

# 11. View from Roundball Hill, Honiton

Roundball Hill is a steep hill sitting high above the south of the market town of Honiton, providing spectacular views over the town, the valley of the River Otter and the high ground of the Blackdown Hills. Being very near my Honiton home, it's a place that I visit regularly for fabulous sunsets set against a backdrop of rolling East Devon countryside.

From the top of Roundball Hill, the small market town of Honiton nestles in the valley below, and when Daniel Defoe visited in 1724, he described the view on

 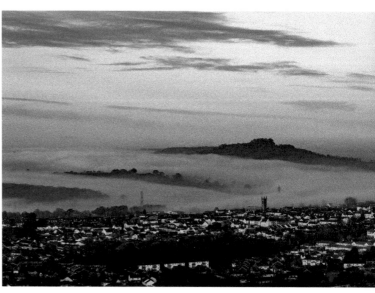

*Above left*: A summer sunset over the East Devon countryside.

*Above right*: A foggy view over the town from Roundball Hill.

*Below*: A snow shower over Honiton from Roundball Hill.

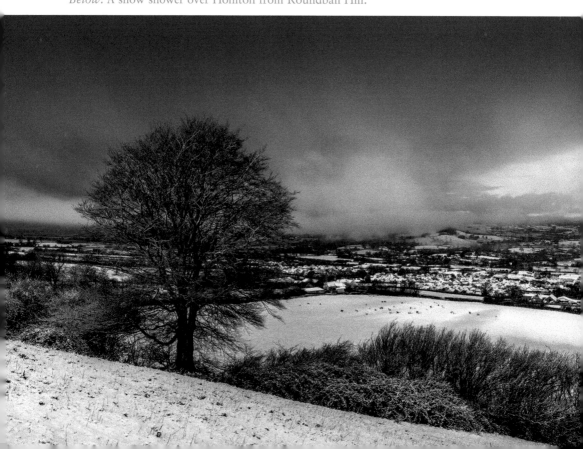

approaching the town as 'the most beautiful landscape in the world'. Honiton's history is intrinsically linked to its position in the landscape, sitting at the crossroads of two Roman roads: one the Fosse Way from the Roman frontier town of Exeter to Lincoln (responsible for the long straight high street that can still be seen today), and another from the Roman signal station at Hembury to the harbour at Axmouth. It would therefore have been a natural place for trade and a natural stopping-off place for travellers before tackling the much more difficult terrain of the Blackdown Hills to the east.

Although it was mentioned in the Domesday Book, the town that we see today began to develop in medieval times, around AD 1200, when the then Earl of Devon laid out a new town around the old Roman Road in order to capitalise on the large number of travellers who passed through. A number of narrow plots were developed perpendicular to the road, so as to maximise the number of tenements that could be built (and hence maximise the rents due!). This classic medieval layout has largely survived the last 800 years, and walking along the High Street today you can still see narrow lanes lined by houses perpendicular to the High Street, as they would have been in medieval times. Despite much of the towns' medieval history having been destroyed by many serious fires, there are still a scattering of ancient buildings to be seen, such as Allhallows Chapel (which is now the museum), and St Margaret's Chapel (on Exeter Road at the western end of the High Street), which are both late medieval in origin.

Whether you visit for the fine small museum that tells how Honiton became famous for its lace, or the street market that was first held in 1257, no visit to Honiton is complete without climbing to the top of Roundball Hill to take in the amazing views. The top of the hill is at grid reference SY 15699 99103, signposted up steps from Roundball lane, just off the A375.

# 12. Exeter's Roman Walls

Having Italian heritage, I have always been fascinated by the Romans. They may have been a conquering force for 400 years of Britain's history, but they also brought with them knowledge and technology that changed the country, including sanitation, medicine and paved roads.

It was AD 43 when Emperor Claudius dispatched 40,000 troops to conquer Britain. With typical Roman efficiency, despite fierce resistance, it took only five years to establish themselves widely throughout central and southern England.

The Romans arrived in Devon around AD 55 and built a wooden fort on a hill above the River Exe near the lowest point where it could be easily crossed. The fort was in the area that is now the city centre and was home to the 5,000-strong Second Augustan Legion. As with many Roman forts, a community would start to grow around it (not least for the profitable trading that could be had with the Roman visitors) and was named Isca Dumnoniorum, after 'Isca', the native Celtic name for the River Exe, and the native Dumnonii tribe, whose ancient home was the South West of England.

For many years it was thought that Isca was a bit of a rural backwater and that Roman influence petered out west of Exeter. However, a number of finds in recent years have suggested that the Roman presence in Devon was more extensive than previously thought. In the 1970s an excavation around Cathedral Green unearthed a large and fine Roman bathhouse, dating from around AD 65, and much more recently an excavation at Ipplepen, to the south west of Exeter, has discovered a high-status Roman butcher's shop and a previously unknown Roman road.

Initially the Roman fort at Isca was defended by earth and timber ramparts, fronted by a deep defensive ditch, but in the second century AD, the fort was extended and a huge rectangular defensive wall was built. The wall was built using stone quarried from an extinct volcano at nearby Rougemont, was up to 3 metres thick and 6 metres high and ran for around 1.5 miles. Although it is heavily repaired with sections from the Saxon, medieval and Civil War periods, and significant damage was done during the Blitz, in large part the ancient city walls have survived the passages of the centuries, with around 70 per cent of the circuit of the wall still remaining today.

Although Exeter doesn't shout about its Roman walls, and as recently as the 1960s some of the wall was demolished to make way for the inner bypass, it is now a Scheduled Ancient Monument and it's worth searching out the impressive sections of 2,000-year-old walls scattered all around the present-day city centre.

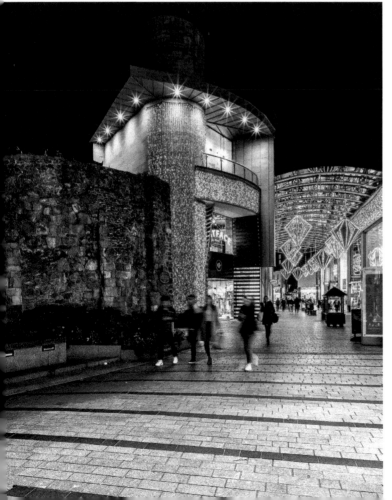

Roman walls next to the Christmas lights of a modern shopping centre.

# 13. The Sea Stacks of Ladram Bay

Sea stacks are a relatively common sight around our coastline, but there can be few as striking or dramatic as the red-sandstone stacks of Ladram Bay.

Ladram Bay lies between the resorts of Sidmouth and Budleigh Salterton, and as is common along the East Devon coast, has a pebble beach. Just off the sheltered beach are a number of rock stacks, some of the finest to be found along all of the Jurassic Coastline.

The stacks are made of iconic red Otter sandstone, formed in the hot dry deserts at the centre of an ancient supercontinent during the Triassic period more than 220 million years ago, and their striking red colour is due to abundant amounts of iron oxide. The Otter sandstones are the richest source of Triassic reptile fossil remains in the UK, and although you're unlikely to find a reptile fossil, a close inspection of the rocks along the back of the beach (or along the sea front at nearby Budleigh) will undoubtedly show you many vertical channels which are the fossilized remains of ancient plants which grew along rivers which crossed the ancient Triassic desert.

The stacks themselves were formed when weaknesses in the rock were eroded by the sea over millennia into caves and rock arches, which later washed away leaving just the stacks.

As a photographer, the iconic stacks make fantastic foreground for coastal shots, and out of season, it's a quiet peaceful place just to sit and listen to the waves rolling onto the pebble beach, and watch sea birds swirling above the rock stacks.

Although Ladram Bay is backed by a large caravan holiday park, it's still well worth a visit. It can be accessed either from the Coast Path by a strenuous but scenic walk from nearby Sidmouth, or via a public footpath which goes from the nearby minor road from Otterton, down the main road through the holiday park to the beach. For a very different view of the rock stacks, and this part of the Jurassic Coast, there are all-year-round boat tours run by Start Line Cruises from nearby Exmouth.

A winter sunrise over the Ladram Sea Stacks.

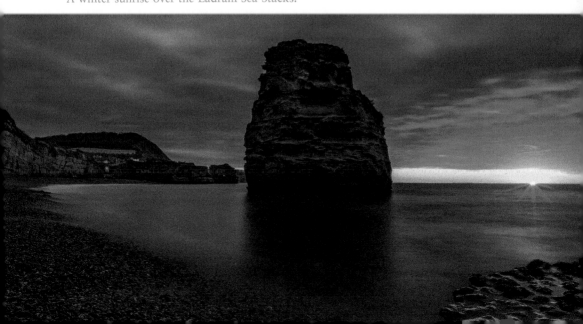

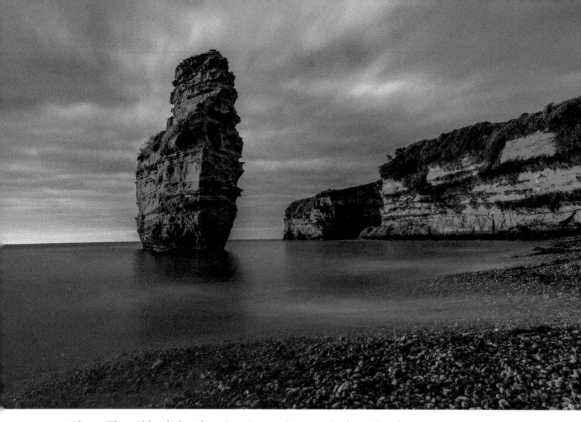

*Above*: The golden light of a winter's morning over Ladram Beach.

*Below*: Stormy summer skies over Ladram Bay.

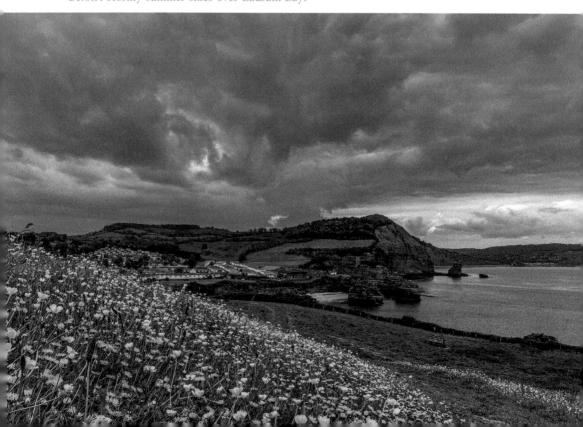

# South West Devon

## 14. Brixham Harbour

Many south Devon coastal communities have a long history of fishing the rich seas around Devon, and there can be no better place to immerse yourself in the history of that seafaring heritage than the bustling town of Brixham.

Even at the time of Domesday in the eleventh century, there was the small settlement of lower Brixham located around a small quay (unsurprisingly nicknamed Fishtown). This was home to a small community of fishermen, catching just enough fish to support their families. However, by the sixteenth century, Brixhams' excellent sheltered harbour and a boom in fishing, brought about by the discovery of the rich Newfoundland fisheries, helped it become the largest and most successful fishing port in the South West.

During the eighteenth and nineteenth centuries, Brixham fishermen were hugely influential and led the way in new fishing technology, including the improved

Sunset over Brixham harbour.

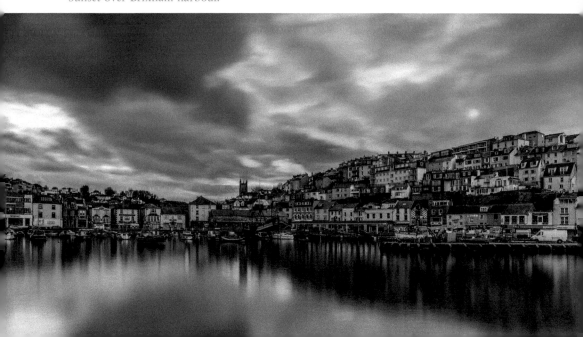

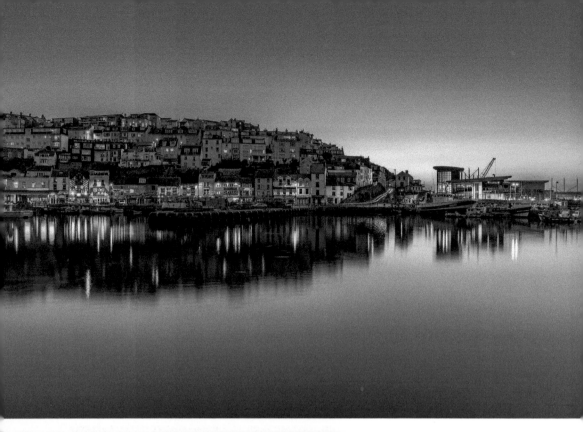

*Above*: A summer dusk over the colourful houses which climb the hill above the harbour.

*Left*: Sunset at the outer breakwater.

Brixham trawlers with their distinctive red sails, coloured by local ochre. Although there has been a slow decline from a peak of 300 trawlers in the late nineteenth century, even today Brixham is one of the busiest fishing ports in the UK, with a handful of modern fishing boats still clustered around the working harbour and a fish market ready to take their catches for distribution across the country.

Brixham harbour also played an unlikely part in a major event in British history, as it was the place where Prince William of Orange and his 20,000-strong army landed on the 5 November 1688, after being badly blown off course by a storm in the channel on their way to London to challenge James II to the crown. After spending the night in Brixham, William and his army marched on London to take the crown in a bloodless revolution and claim the throne of England. The arrival of William of Orange was to be a major event in British history, as the last successful invasion of England and for establishing the first constitutional monarchy.

Today there is a statue at the harbour marking the stone upon which William was said to have first stepped ashore. There are a number of other echoes of this historic event, with several Dutch road names around the town and many Dutch surnames amongst Brixham residents, suggesting that after their unexpected arrival, a number of Williams's army decided to make the town their home.

It's a great place to sit and watch the fishing boats coming and going, or even sample some of the catch by grabbing some fish and chips from one of the shops around the harbour. As a photographer it's hard not to love Brixham harbour for its pastel coloured fisherman's cottages, which climb the hillside above the harbour, and the beautiful reflections that can often be seen in the still waters of the harbour at high tide.

# 15. The River Erme Estuary

If you love rivers then a visit to the Erme really has to be on your list. Most of the river estuaries of South Devon are developed places, surrounded by towns, villages and busy tourist beaches; however, the Erme is different in being a remote and peaceful place to enjoy nature and the natural river environment. Although there are roads to both sides of the river, they are narrow rural lanes, and so out of season you are unlikely to encounter more than a few local dog walkers.

The River Erme rises in the centre of Dartmoor, flowing south through Ivybridge, Modbury and Holbeton before meeting the English Channel a few miles west of Bigbury-on-Sea. Although the Erme looks entirely natural today, much of the upper reaches of the river have been significantly modified by the extraction of tin deposits from the riverbed, a Dartmoor industry that began in ancient times and continued right through to the early twentieth century. The river's role in this ancient industry was confirmed by a number of tin ingots discovered in the mouth of the estuary in the early 1990s and dated to between 500 and 600 BC.

I remember the Erme well from my time walking the South West Coast Path, as it's the only river in the South West that has no ferry or viable way of walking upstream

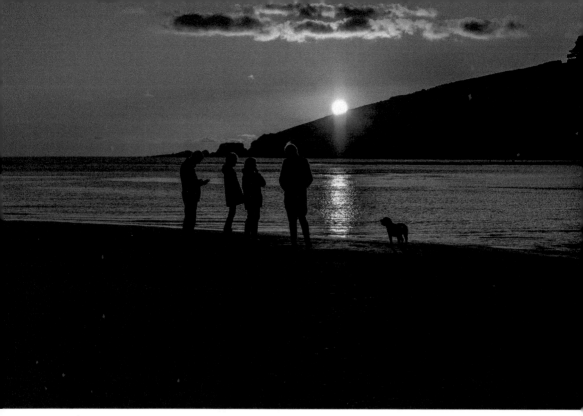

*Above*: Sunset on Wonwell Beach at the mouth of the River Erme. (Image by Gary Holpin, used with kind permission of Coast & Country Cottages)

*Below*: The beautiful River Erme Estuary.

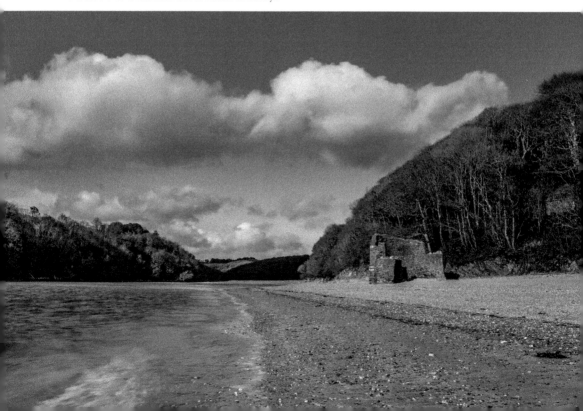

to the nearest bridge; the only way to cross it is to wait until high tide and cross it using stepping stones, and even then you're likely to get your feet wet!

The Erme Estuary has beautiful expanses of sand revealed at low tide (known as Wonwell Beach) and is a place of peace and tranquillity away from the busier parts of the South Devon coast. On the western side of the entrance to the estuary is the beautiful Mothecombe Beach, which has a wide sandy beach and plenty of coves for rock pooling. It's a private beach and only open on certain days, so it's worth checking before you visit.

The Erme Estuary is at grid reference SX 61586 47455, and there is a pay and display car park at Mothecombe (signposted from Holbeton) which is open in the summer months.

# 16. Salcombe

Salcombe has become one of my firm favourite South Devon locations since I first discovered it whilst walking the Coast Path, and it has to be a must-visit location for any South Devon visitor. Although a busy and popular town situated on the Kingsbridge estuary in the South Hams, it is also undoubtably one of the prettiest towns in South Devon.

The town climbs up the steep western side of the beautiful Salcombe-Kingsbridge Estuary, which is actually a ria, or flooded valley, that runs inland from the coast to

Salcombe from East Portlemouth.

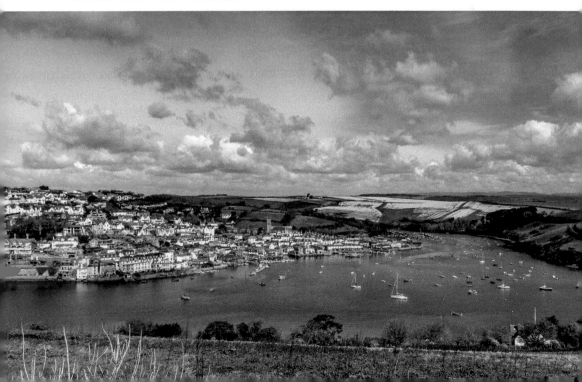

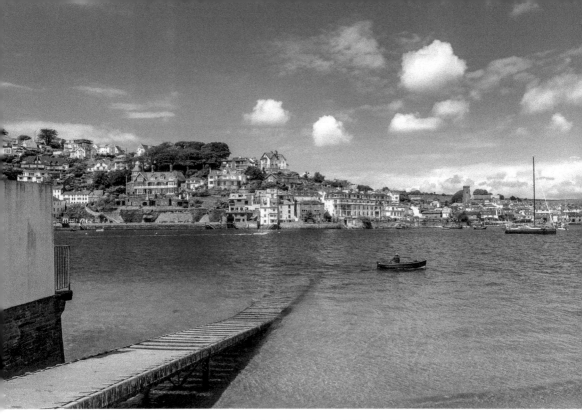

*Above*: The stunning azure waters of the Salcombe and Kingsbridge estuary.

*Below*: Summer sailing boats at Salcombe.

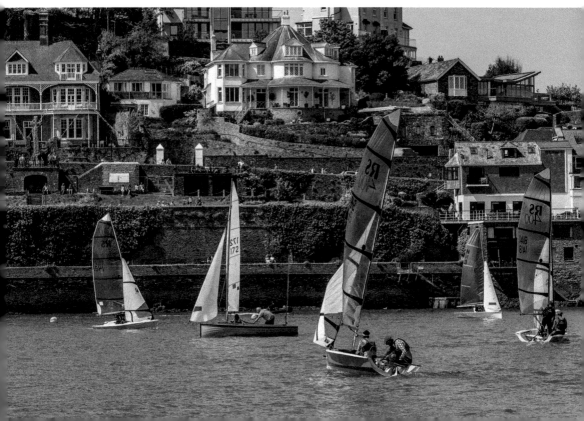

nearby Kingsbridge. The golden sands of the estuary help to make the waters around Salcombe some of the clearest and azure blue anywhere in Devon. There are fine beaches on the Salcombe side at both North Sands and South Sands, and crossing the estuary using the all year-round ferry takes you to East Portlemouth and more glorious sandy beaches at Fisherman's Cove and Mill Bay. The sheltered waters around Salcombe are also perfect for water sports, and in the summer months the estuary is filled with colourful yachts and kayaks.

Visitors to South Beach will see the remains of Salcombe Castle (also known as Fort Charles) on a rocky outcrop at the north end of the beach. Originally built by Henry VIII in 1544 to defend the estuary from attack by Spanish and French pirates, the castle played an important role in the English Civil War of the mid-seventeenth century, when it was used as a Royalist stronghold. The castle withstood two major sieges, the second lasting more than four months, and was the last place in Devon to hold out to Parliamentarian troops before an inevitable surrender in 1644. The castle was seen as too dangerous to remain as a fortification, and parliament later ordered its destruction.

As with many Devon towns, the Second World War left its mark on Salcombe, with damage caused by numerous bombing raids. However, the town's main role was in the closing stages, when it became a centre for preparations for the Normandy landings, which would signal the start of the end of the long and bitter war. From the end of 1943, Salcombe became an advance amphibious base for the US Navy, and much of the town was requisitioned for naval use. A slipway was built at Whitestrand Quay, and on 4 June 1944 sixty-six ships sailed for Utah Beach to begin the attack on German occupied France.

Today, Salcombe is a thriving town, crammed with visitors during the summer months, with narrow streets filled with independent shops and many fine bars and restaurants with stunning riverside views. As long as you're not looking for quiet and seclusion, Salcombe is a must visit location, especially when the sun is shining, lighting up the azure blue waters of the estuary.

# 17. The Daymark Tower

If you like a fine bit of Victorian architecture with even finer views then I highly recommend a visit to the Daymark Tower. Situated on a hill high above Kingswear, and a short walk inland from the Coast Path at Froward Point, the Daymark is built in typical Victorian fashion, being functional as well as beautiful.

The Daymark Tower is a 24-metre-high, hollow, octagonal limestone tower that was built in 1864 as a day beacon to help ships find the entrance to the Dart Estuary, which is notoriously difficult to find on the craggy coastline. As well as being a fine piece of architecture, there are fabulous views to admire around the Daymark, both to the east over Start Bay and to the west over the Dart Estuary to Dartmouth.

After a visit to the tower, it's worth a walk down the tarmac road to the coast where the scatter of buildings of Brownstone Battery is also well worth a visit.

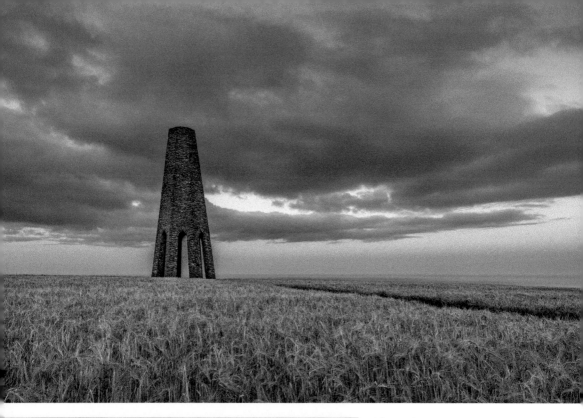

*Above*: A summer sunset at the Daymark Tower.

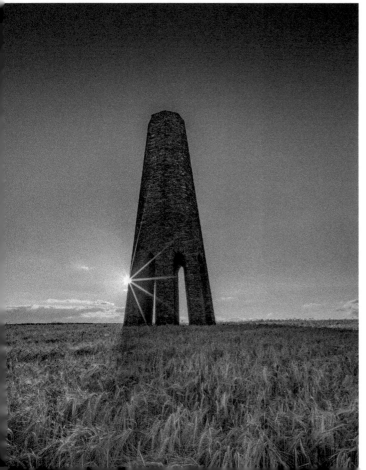

*Left*: The sun sets behind the Daymark.

Brownstone is one of only a few remaining Second World War coastal defence positions, built in 1940 to counter the threat of a potential German invasion. The battery was one of more than 100 gun emplacements built along the south coast, and was manned by soldiers from the 52nd Bedfordshire Regiment, who spent their time preparing to protect the Dart Estuary from an invasion which ultimately never materialised. The battery had two gun positions, both armed with 6 inch guns recovered from First World War battleships, which were capable of firing more than 14 miles out to sea. Also, still on the site are buildings that housed powerful searchlights capable of scanning the sea for enemy ships, rail tracks that were used to transport shells from the ammunition store to the gun emplacements, lookout towers, and even the mess building, which kept the soldiers fed and watered.

As part of the extensive defences of this stretch of coastline, nearby Dartmouth Castle had a battery of 4.7 inch guns. There was also a machine gun emplacement at Kingswear Castle and an anti-aircraft emplacement on Jawbones Hill above Dartmouth.

To get to the Daymark and Brownstone, park at Brownstone Car Park (grid reference SX 90449 50996) and follow the tarmac road down to the tower. Continue down this road to visit Brownstone Battery.

# 18. Cockington

For a chocolate box English village, Cockington fits the bill perfectly. Only half a mile from bustling Torquay seafront, the village is tucked away in a narrow wooded valley and gives the impression of not having changed drastically since it was mentioned in the Domesday book. There's a watermill, narrow lanes lined with thatched cottages, a forge and a grand country manor with a cricket pitch in front. In fact, everything you would expect from a quintessentially English village.

Cockington has been on its current site for over 1,000 years and has its origins in Saxon times. By the time of Domesday in 1086 it was owned by the Norman William de Falaise and was a rich estate extending to the coast and employing thirty-eight men including eighteen villeins (tenants), six bordars (smallholders) and fourteen serfs (servants).

The current Cockington Court was built by the local influential Cary family in the late sixteenth century, and although extended and remodelled over the centuries, on the north face of the north wing there is a beautiful original Tudor doorway that used to lead into the kitchen and the tiny servants' quarters. The house is said to be haunted by Sir Henry Cary, who bemoans the loss of his ancestral home at the end of the English Civil War after he backed the losing side! The house is now owned by Torbay Council and used as offices and craft workshops. It is a great place to stop by for a coffee and enjoy views of the extensive parkland.

Adjacent to the house, hidden among trees, is the small church of St George and St Mary, which has been used for worship largely as a private chapel since it was built by Willian de Falaise in the eleventh century.

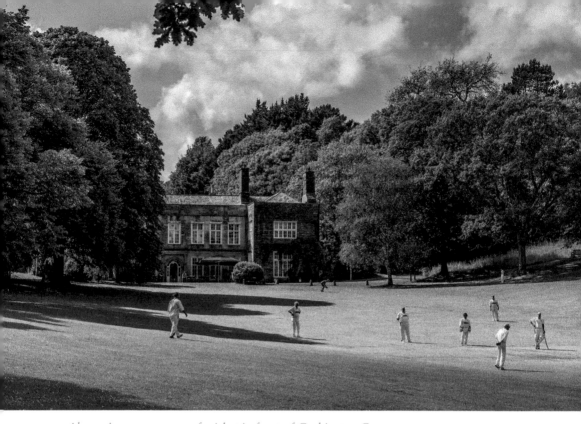

*Above*: A summer game of cricket in front of Cockington Court.

*Below*: Thatched cottages in the picturesque centre of the village.

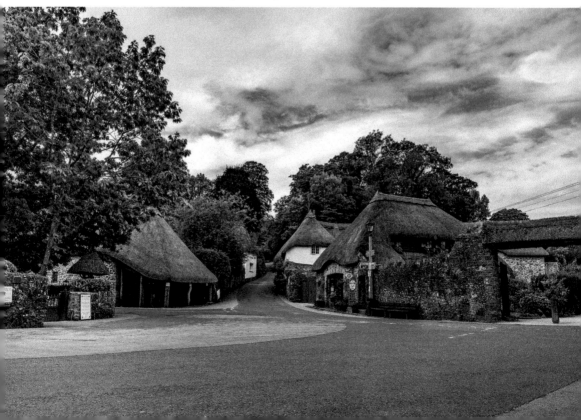

Before the coast road between Torquay and Paignton was built, the road through the village was the main route between the two and so would have been busy with trade between the two towns. In the centre of the village square is the forge, providing ironwork such as horseshoes since the fourteenth century and now probably one of the most photographed buildings in Britain! A pond, which used to be in front of the forge, was also home to the village ducking stool, used to punish criminals in medieval times by being strapped to a chair and dunked in the pond.

Although Cockington can be very busy in the summer season, it's still a place where you can find some tranquillity by heading to the lawns in front of the manor house to relax watching a game of cricket.

# 19. Dartmouth Castle

For a sense of history you can't beat a visit to a traditional English castle, but not all of them have the fantastic views of Dartmouth Castle. The picturesque fortress sits on a rocky headland above the River Dart, where it has been guarding the entrance to the estuary and the port at Dartmouth since the fourteenth century.

With its excellent deep-water harbour, Dartmouth has been a port for thousands of years, and by the twelfth century the town was thriving from its trade in wine and cloth. Fearing that Dartmouth was at risk of attack from the French, the then mayor of the town, John Hawley, successfully petitioned the king for funds to build fortifications to protect the town.

Dartmouth Castle sits overlooking the entrance to the Dart Estuary.

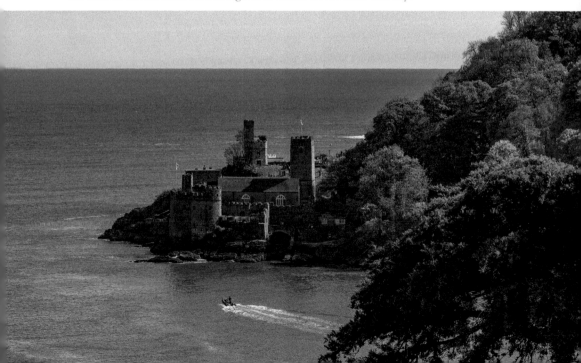

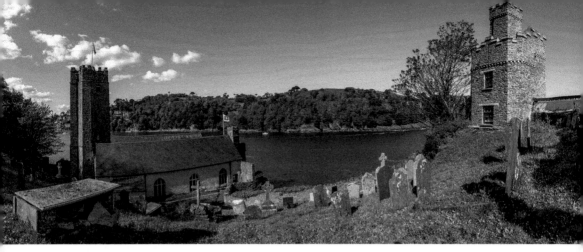

The Castle and St Petrox Church.

In 1388, the first fortified enclosure was built on the Dartmouth side of the entrance to the narrow estuary and was a simple ring of towers enclosed by a curtain wall (some of which still remains in the present-day car park). Initially the castle's defences were just simple stone throwing catapults designed to attack any enemy ships entering the river; however, in 1481 an imposing gun tower was added, which was probably the first fortification in Britain to use special heavy cannon called 'murderers' designed specifically to sink ships. Around 1491, a heavy chain was added, which stretched across to the new fortification of Kingswear Castle on the opposite side of the river. Although the purpose was said to be to hold up enemy ships long enough to attack them, it was also used to prevent merchant ships leaving Dartmouth without paying their taxes.

One of the most striking buildings within the castle grounds is the ancient St Petrox Church, named after the Welsh St Petroc. The church predates the castle, beginning life as 'the monastery of St Peter' in 1192. It is likely that the monks of the early monastery would have supplemented their income by maintaining a navigation light to guide ships into the estuary. Its picturesque sloping graveyard contains the remains of many of Dartmouth's eminent merchant families.

The castle and the church are both well worth a visit, both for their historical interest and for the fantastic views of the estuary and beautiful rugged coastline that surrounds them. The castle can be found by following the B3205 past Bayard's Cove Fort (another of Dartmouth's historic fortifications) and then turning left onto Castle Road, from where the castle is signposted. There is also a seasonal ferry that runs the short distance from the nearby town.

# 20. The Stoke Gabriel Yew

If, like me, you love trees and marvel at the history that truly old trees have lived through, then a visit to the thousand-year-old Stoke Gabriel Yew will definitely be for you.

There is something truly amazing about trees; as well as their majestic structure and obvious beauty, they are also some of the oldest living things on our planet. Although not always easy to measure, one of the oldest individual trees in the world

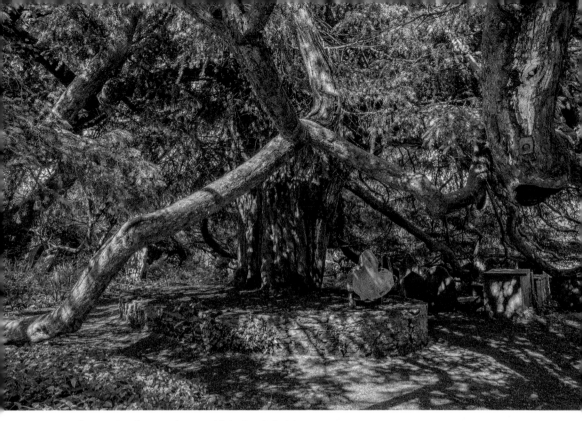

*Above*: The thousand-year old Stoke Gabriel yew.

*Below*: The huge yew sits alongside the Saxon church.

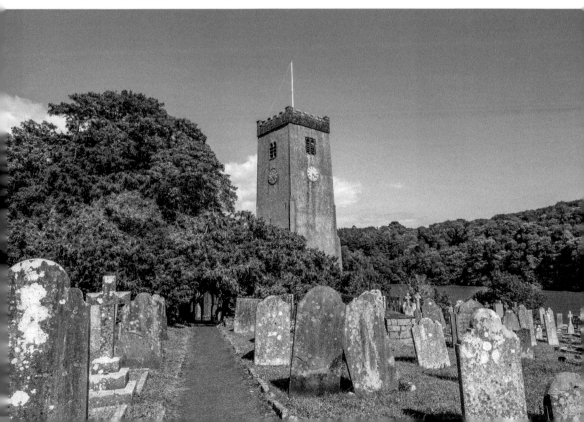

is the Great Basin bristlecone pine in the White Mountains of California, called Methuselah, dated at 4,851 years old – older than the Pyramids of Giza! Although a mere youngster at only around 1,000 years old, the yew outside the door to the church at Stoke Gabriel is truly ancient and one of the oldest trees in Britain.

The yew is our longest living tree species, and is not even considered as ancient until it reaches at least 800 years old. The Stoke Gabriel Yew was planted at around the time of the Norman Conquest of England, and has witnessed many major events in Britain's history, including the signing of the Magna Carta in 1215, a third of the English population being wiped out by the black death in the mid-fourteenth century, and the crowning of Elizabeth I in 1558.

Sadly, most of our ancient woodlands have disappeared, and in those that remain, most old yews were cut down for the manufacture of longbows for the British armies between the thirteenth and sixteenth centuries. It is thought that yew trees were often planted in churchyards (many of which are on the site of pre-Christian sites) due to the tree's longevity being linked to everlasting life in Druidic Britain and a symbol of resurrection in later Christian religion. Many of our ancient yews are found in churchyards because of the protected nature of these sites over many centuries.

The Stoke Gabriel yew is almost 6 metres around the base and is adjacent to the church of St Mary and St Gabriel. The church dates from Norman times, suggesting that the tree may have been planted around the same time that the church was founded. Legend has it that if you walk backwards seven times round the yew's main stem you will be granted a wish.

As well as a visit to the yew, the wider village of Stoke Gabriel is also worth exploring; it's a picturesque village situated on a creek of the River Dart, has lovely river views and is surrounded by the beautiful rolling countryside of the South Devon Area of Outstanding Natural Beauty.

# 21. Teignmouth Pier

Sadly, there are now only a handful of traditional Victorian piers left in the South West, with more than half of British piers disappearing since the turn of the twentieth century. One of the finest remaining piers is at Teignmouth, where you can still enjoy a stroll along the 212-metre-long grand pier and try your luck in the traditional penny arcade.

Teignmouth was a flourishing tourist resort in the mid-nineteenth century when plans were drawn up for a pier, which was seen as an essential for any serious Victorian seaside resort. A simple timber promenade deck above a framework of cast-iron piles was completed in 1867, which was constructed primarily as a landing stage for holidaymakers to board pleasure steamers that offered tours of the coast as far as Plymouth and Weymouth. Later, some Victorian entrepreneurs set up refreshment stalls on the pier to relieve Victorian holidaymakers of their holiday money.

The location of the pier, in the centre of Teignmouth's red sandy beach, was a convenient dividing line for bathers, with gentlemen bathing to the west and ladies

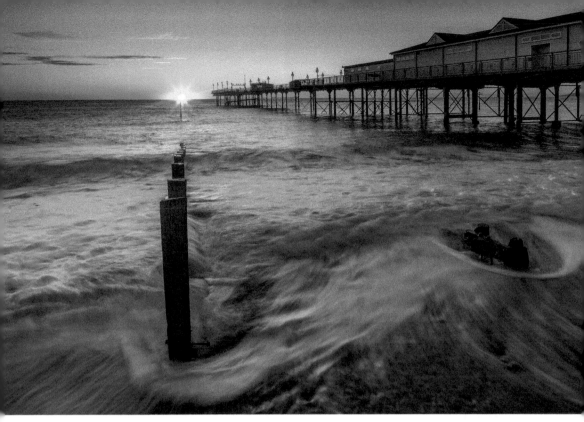

*Above*: A winter sunrise on Teignmouth beach.

*Below*: Moody summer skies over the pier.

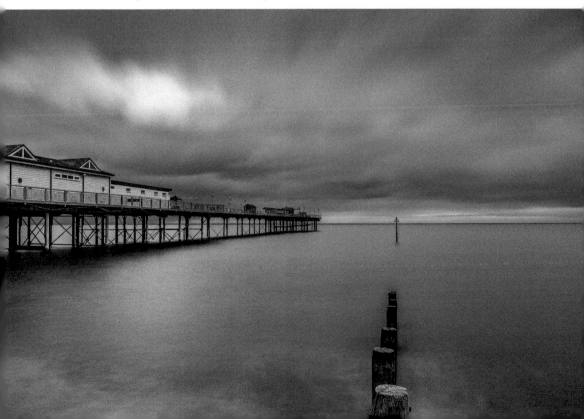

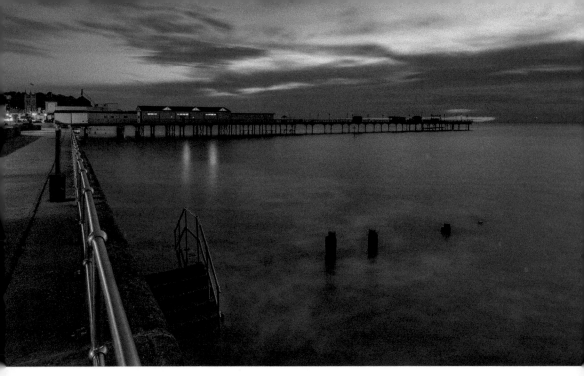

A winter's day dawns on Teignmouth seafront.

to the east. At the time, bathing machines would have been a familiar sight on the beach. The bathing machine was a hut on wheels that was used to ensure the modesty of beach goers, allowing them to change into their bathing gear before being wheeled into the water to slip unseen into the waves.

Teignmouth pier has had more than its fair share of mishaps over the years: in 1904 the entrance kiosks collapsed onto the beach; the jetty was removed during Second World War to prevent the Germans using it as a landing stage; and in 2014 many of the amusements were destroyed by storms. Despite this, and after substantial renovation, Teignmouth pier remains a gem of South Devon, and is well worth a visit for that traditional British seaside experience.

As a photographer, Teignmouth pier is a fantastic location; the pier adds interesting foreground to moody skies, to a glorious sunrise, or to stormy seas, and is one of my favourite locations to sit and watch a winter sunrise.

# 22. The Great Western Railway

The journey by train along from Exeter, along the length of the Exe Estuary, and then right along the coast from Dawlish Warren to Teignmouth has got to be one of the finest and most iconic train journeys in Britain, and most certainly a gem of South Devon.

The line was built by the amazing Victorian engineer Isambard Kingdom Brunel. During his career, Brunel designed and built some of the wondrous structures of Victorian Britain, many of which we still know, love and even still use today – from

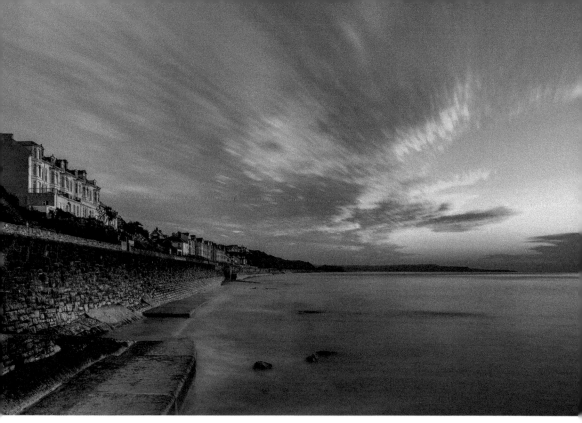

*Above*: A colourful sunrise over the GWR at Dawlish.

*Below*: A train speeds along Brunel's railway at Dawlish.

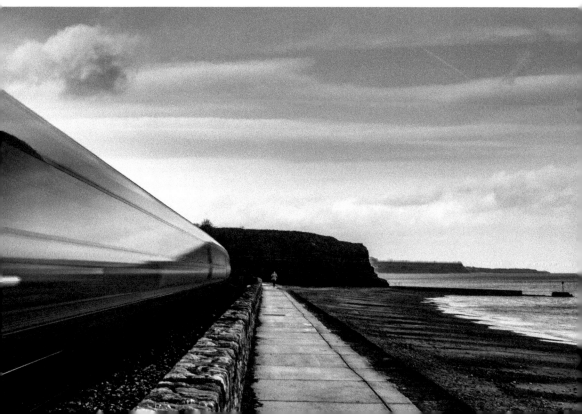

Bristol's Clifton Suspension Bridge and the great steam ship the SS *Great Britain* to the amazing Great Western Railway. This stretch of the railway initially brought mass tourism to the South West in the nineteenth century and is a must-do experience for any visitor to South Devon today.

The Great Western Railway started with the stretch from London to Bristol in 1841, which included the amazing engineering feat of the 2-mile-long Box Tunnel, east of Bristol. The tunnel took 4,000 men five years to dig by hand through solid Bath stone, using a ton of candles and a ton of gunpowder every week. The success of the line led almost immediately for calls to extend the line into the South West, and in 1844 the first train ran from Paddington to Exeter, and then on to Plymouth by 1848. Brunel's construction plans included the difficult section from Dawlish to Teignmouth where the track had to be laid between the sea and the cliffs and involved the building of a huge sea wall to protect the line.

Although Brunel was a brilliant engineer, not all of his ideas were so successful. He initially introduced the so-called atmospheric trains on the South Devon line, pulled along by a vacuum in a metal tube. The vacuum was created by engine houses, one of which can still be seen beside the line at Starcross. Sadly, although the idea was technically sound, Victorian engineering materials were not up to the job, and leather seals kept failing, so that more often than not the trains didn't work and were eventually replaced by more conventional steam engines.

The battle to save this fine scenic section of railway from rising seas and eroding cliffs is becoming increasingly difficult, and new plans to try and protect the line may sadly decimate the beach and change the character of the location for ever. However, for now it is well worth a visit by train from Exeter, or you can enjoy the views at a more sedate pace on foot with a walk along Brunel's sea wall at Dawlish or Teignmouth.

# 23. The Spanish Barn

A short walk from the bustling seafront at Torquay is a true gem in the shape of the fine late medieval building known as the 'Spanish Barn'. The barn is part of Torre Abbey, the oldest building in Torquay and the most complete surviving medieval monastery in Devon. Founded in 1196, the abbey became one of the wealthiest monasteries in Britain, earning a staggering £1.8 million per year by the end of the fifteenth century (the equivalent of a billion pounds today). This vast wealth enabled them to develop Torquay's first harbour, as well as the nearby market town of Newton Abbot, in order to sell produce from their extensive lands.

The abbey's tithe barn was built around 1200 to hold taxes paid to the abbey in the form of grain and other produce. However, it wasn't until 1588 that the barn gained its name, when it became involved in the history of the Spanish Armada.

In 1588, Phillip II of Spain sent a massive 130-ship fleet to invade England. After Sir Francis Drake finished his famous game of bowls on Plymouth Hoe, the English Navy tackled the approaching fleet. Knowing the Spanish were at their best fighting at close quarters, Drake used an old navy trick of sending burning ships loaded with tar and gunpowder towards the Spanish fleet to scatter them while firing from a safe distance.

Mayhem ensued as the Spanish retreated, attempting to escape the long way via the North Sea and around the top of Scotland. In the battle the English Navy did not lose a single ship; however, half of the Spanish fleet were lost during their attempt to get back to Spain.

*Above left*: The Spanish Barn bathed in late afternoon sunshine.

*Above right*: High barn doors to allow carts loaded with grain to enter.

*Below*: Torre Abbey.

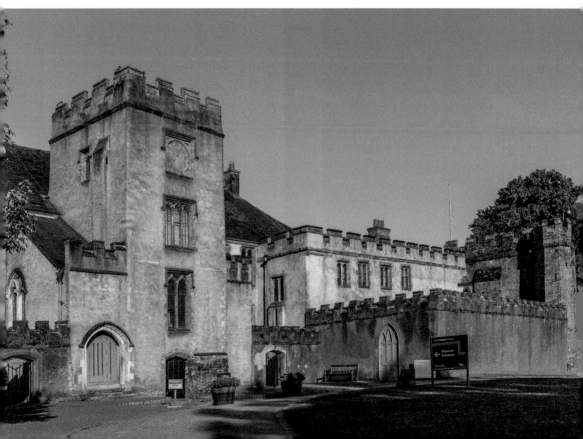

During the fight, the Spanish flagship the *Neustra Senora del Rosario* was severely damaged and, along with her valuable treasures of gold coins, wine and munitions, surrendered to the English. The ship was towed into Torbay and 387 captured soldiers were brought ashore and imprisoned in the abbey barn, giving it the nickname of the 'Spanish Barn' that has survived through the centuries. Conditions for the prisoners in the barn were appalling, and a number of prisoners died during their imprisonment. However, those who survived were eventually ransomed and returned to Spain. This was a far better fate than those who were captured while fleeing around Ireland, up to 5,000 of whom were put to death.

The Armada prisoners were not welcome in Torbay; as well as being would-be invaders, the locals blamed them for eating their food, and as a result, many rumours about them began to circulate. One was that of the 'Spanish Lady', the fiancé of one of the ship's lieutenants, who, not wanting to be separated upon capture, had disguised herself as a sailor. After being imprisoned in the barn, she later died and her ghost is said to have roamed the Spanish Barn ever since.

So, if you're looking for some quiet away from the hustle and bustle of Torquay, the abbey and barn are well worth a visit, but do keep a look out for the Spanish Lady. The barn can be found just off the seafront near Abbey Park.

# 24. Elberry Cove

Torbay is a busy place with the bustling seaside resorts of Torquay and Paignton, but there are still spots nearby where you can get away from the crowds and enjoy some rural peace and tranquillity. Elberry Cove, midway between Paington and Brixham, is one of those places. The cove has a small shingle beach, is surrounded by beautiful wooded hillsides, and is only accessible on foot, so it never gets too busy.

At one end of the cove are the ruins of a bathing house (often called 'Lord Churston's Bath House'), which was built around the turn of the nineteenth century for the lords of nearby Churston Estate to change into their bathing costumes and enter the sea while preserving their modesty. Elberry Cove was also a popular bathing spot of author Agatha Christie, who used to visit when staying at her nearby holiday home at Greenway. It is also an important location for beds of eelgrass, a plant that lives on sandy seabeds in shallow waters and provides an important habitat for sea life such as seahorse and pipefish.

Nearby Churston Court is now a hotel, but dates back to the twelfth century, and according to legend there were tunnels connecting it to the beach for use by smugglers. The house has also had some famous visitors over the years, including Sir Walter Raleigh, Agatha Christie and Bruce Reynolds, the mastermind of the Great Train Robbery, who hid at the house while on the run from the law in 1963.

The easiest way to get to Elberry Cove is to park at nearby Broadsands beach and walk along the Coast Path for around half a mile. Do be aware that as the cove is well sheltered it's popular with jet skis and water skiers, so make sure not to swim in the well-marked ski lane.

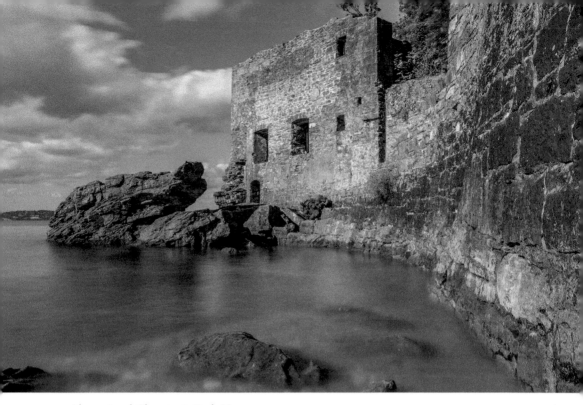

*Above*: Lord Churston's Bath House.

*Below*: Beautiful and secluded Elberry Cove.

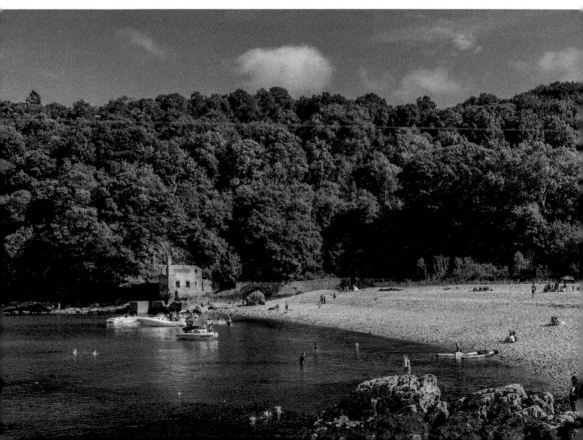

# 25. Slapton Sands

Slapton Sands is one of the longest beaches in South Devon and is undoubtedly one of the most picturesque. Its shingle beach curves more than 2 miles along Start Bay from Torcross to Strete Gate, has fantastic views along the coast north towards Dartmouth, and is backed by Slapton Ley, the largest freshwater lake in the South West.

The Ley was formed more than 3,000 years ago as sea levels rose, forming a pebble ridge that dammed a stream, creating a freshwater lake. The Ley is a National Nature Reserve and one of Britain's most important wetland reserves, home to a wide variety of native wildlife including otters, bats and butterflies.

At the southern end of the beach is the picturesque village of Torcross. Along with many other villages in the area, in 1943 the residents of Torcross were evacuated to make way for the arrival of 30,000 troops, as the bay became the centre of preparations for the D-day landings. Start Bay had been chosen for this role due to its similarity to the beaches of Normandy. On 28 April 1944, part of the D-day rehearsal called Operation Tiger was taking place, when a group of German E-boats stumbled across the operation and attacked, killing almost a quarter of the 4,000 allied troops. So as not to jeopardise moral at such a critical time, the tragedy was covered up, and on 6 June the allied invasion of Normandy went ahead as planned, marking the start of the end of the Second World War. One of the Sherman tanks lost at sea in

Slapton Sands with the Ley behind, viewed from Torcross.

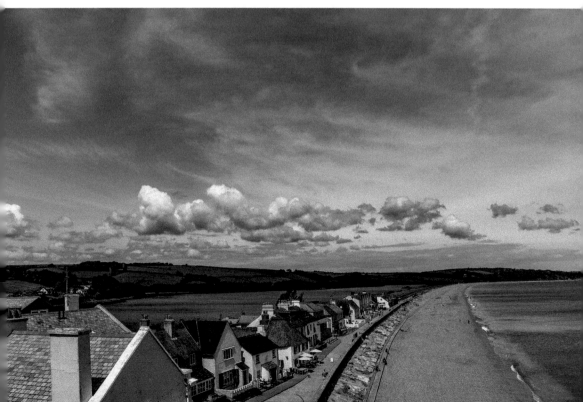

The tank at Torcross, an unofficial memorial to the lives lost in Operation Tiger.

Operation Tiger was later recovered from the sea and now stands in the car park at Torcross as a memorial to all of those who were tragically lost.

Start Bay is one of the most exposed parts of the South Devon coast, and is vulnerable to huge storms. In 1979 there was was a storm with waves so large they washed right over the roofs of the houses, leading to the building of the present sea wall. Nearby Hallsands, a short distance south, was not so lucky; a vibrant fishing village with a population of 159 in the late nineteenth century, a major storm in 1917 destroyed most of the buildings and the village was evacuated. There is very little left now except a visitor platform above what is left of the village, perched high above the sea.

No visit to South Devon is complete without a visit to the beautiful scenic Slapton Sands and taking a few minutes at the memorial to remember those who lost their lives in the nearby waters of Start Bay.

# 26. Plymouth Hoe

The next gem of South Devon is probably one of the most recognisable locations in the whole of Devon: the historic Plymouth Hoe. The Hoe, whose name is derived from Anglo-Saxon English meaning 'sloping ridge', is an area of parkland with fabulous views over Plymouth Sound, Drake's Island and across to the Cornwall coast.

Standing high above the Hoe and visible for miles around is the iconic red and white striped Smeaton's Tower. Originally built in 1759 as a functioning lighthouse on the Eddystone reef, the lighthouse was lit by twenty-four candles – which must have been pretty ineffective in thick fog! In 1877 when its foundations began to break up, the top of the tower was moved stone by stone and rebuilt in its current location. On fine days the replacement lighthouse, built in 1882 and still warning ships off the dangerous Eddystone rocks, can just be seen on the horizon.

With its strategic position high above Plymouth Sound, the Hoe has been the place where some of the most important chapters in Britain's history have unfolded.

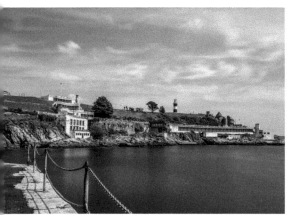 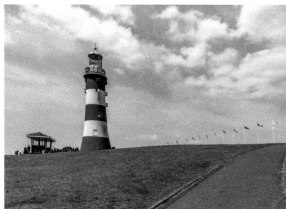

*Above left*: The waterfront at Plymouth Hoe.

*Above right*: The iconic Smeaton's Tower.

*Below*: Sunset over Plymouth Sound.

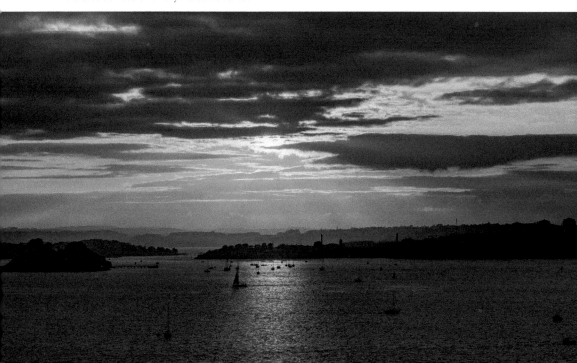

It was famously the place where the Elizabethan sea captain, Sir Francis Drake, was said to have insisted on finishing his game of bowls (which he apparently lost) before heading off to successfully see off the invading Spanish Armada. It's also the place where the impressive Royal Citadel (built on the site of an earlier Tudor fortress) has protected this critical location in the nation's defence from the seventeenth century to the present day.

It was from Plymouth Sound that Sir Francis Drake set off to circumnavigate the globe on the galleon the *Golden Hind*, between 1577 and 1580, and claimed what is now California for the English. Below the Hoe, in the area around the Barbican, are the famous Mayflower Steps, where the Pilgrim Fathers are said to have left England in 1620, fleeing religious persecution in Holland and sailing onboard the *Mayflower* to found Plymouth Colony in America. The story of the Pilgrim Fathers was to become a key story in the history and culture of the United States.

It may be a stones' throw from the hustle and bustle of Plymouth, but the Hoe is still a peaceful place to sit and take in the fantastic views over the Sound and walk in the steps of some of those who shaped the history of our nation, many of whose statues now line the back of the Hoe.

# 27. Burgh Island

The popular Burgh Island, a small tidal island off the coast at Bigbury-on-Sea, is a real gem of South Devon and definitely worth a visit for its beautiful sandy beaches, picturesque views and for a cold beer at the aptly named Pilchard Inn.

Situated at the mouth of the River Avon, the small rocky island of Burgh (pronounced 'Burr') Island is accessible on foot across a sandy causeway at low tide, or by hitching a ride on the ingenious sea tractor if the tide is in.

Some of the earliest inhabitants of the island were the monks of a monastery, the remains of which lie under the Burgh Island Hotel. The nearby Pilchard Inn is believed to date from fourteenth century and is thought to have been originally built as lodgings for the monastery. The hotel itself is a fine art deco building and has been visited by some of the twentieth centuries' most iconic figures, including Churchill and Eisenhower (who met there to plan D-day), Edward and Mrs Simpson, and Agatha Christie.

In earlier times, the island was said to be a base for smuggling, with a tunnel said to connect the Pilchard Inn to the shore, allowing illicit goods to be brought in under the cover of darkness. There is a local legend that says that the law caught up with one of the most renowned Elizabethan smugglers called Tom Crocker on the island. He is said to have been shot in the doorway to the Pilchard Inn, and his ghosts still haunts the inn.

The final building, right on the top on the island, is the derelict remains of a chapel, which was later used as a 'huers hut', a place where a lookout would keep watch for shoals of Pilchards, issuing a 'hue and cry' to alert their fellow fishermen of a potential catch.

Although a bit of a climb, there are fine panoramic views from the top of the island, towards Wembury, the Avon Estuary and the fine beaches at Bantham. On the way back down, don't forget to cool off with a cold drink at the Pilchard Inn.

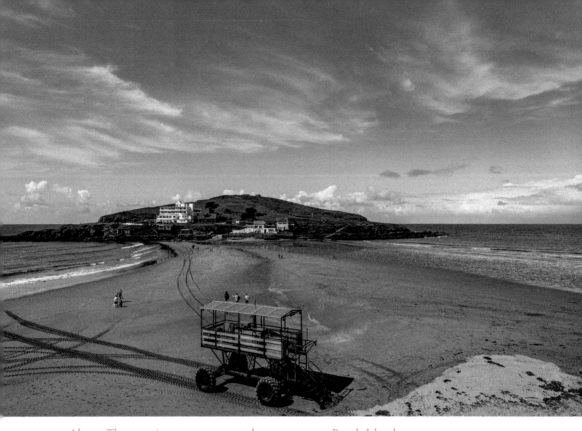

*Above*: The amazing sea tractor on the causeway at Burgh Island.

*Below*: Waves wash upon Bigbury beach.

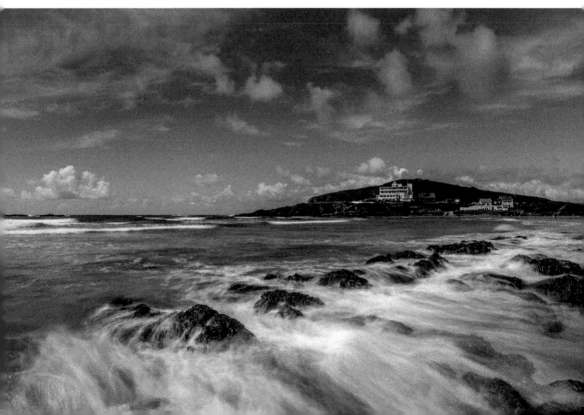

# 28. Plymouth National Firework Championship

This gem can only be experienced once a year, but if, like me, you love fireworks, then it's a must-visit event. Every year since 1997 (despite one year when an unexploded Second World War bomb almost scuppered the event) Plymouth has hosted an annual competition where Britain's best firework companies get to demonstrate their skills. Plymouth was chosen for the excellent natural amphitheatre of Plymouth Sound, where the fireworks can be safely fired over the sea, with plenty of vantage points around Plymouth Sound to watch the amazing displays.

Every August, thousands of people flock to the city, and as darkness falls over the Hoe, expectations rise until, with a flash and a bang, the skies over the historic Hoe light up with some of the best firework displays around. The competition is held over two nights and is a feast of pyrotechnics.

Fireworks have been around a very long time, with their first use in China around AD 800 when saltpetre, sulphur and charcoal were first mixed to create a basic gunpowder. Pyrotechnicians were quickly respected for their skills with such dangerous materials, and firework displays soon became associated with special occasions such as festivals.

*Below left*: The first firework of the 2019 Championship.

*Below right*: A fantastic pyrotechnic display over the Hoe.

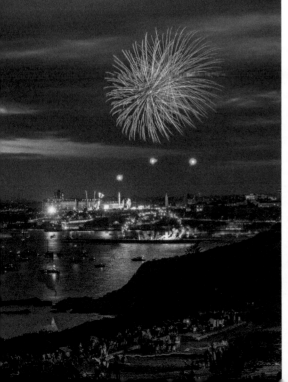
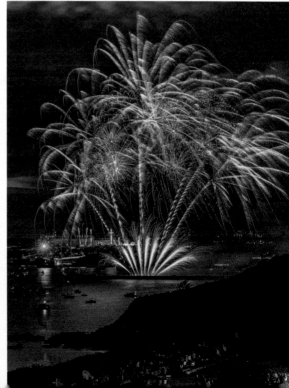

Around the thirteenth century the recipe for gunpowder reached Europe, and although its primary use was in munitions for warfare, use in fireworks soon became widespread throughout medieval England. Kings in particular would use fireworks to entertain their followers, with the first royal firework display used to celebrate Henry VII's wedding day in 1486.

We are most familiar with fireworks around 5 November, when for centuries we have celebrated the failed Gunpowder Plot of 1605. At the time, England was Protestant, and Guy Fawkes and his fellow plotters wanted to return the country to Catholicism by killing James I and his ministers. The gang placed thirty-six barrels of gunpowder in a cellar under the Houses of Parliament, ready to implement their bloody plan, but they were foiled when one of the plotters sent a warning to a friend in Parliament to stay away on 5 November. Guards then tracked down and arrested Guy Fawkes and his fellow plotters, and they were tortured and executed for their attempted crime.

On 5 November 1605, bonfires were lit across the country to celebrate the safety of the king and it is this tradition that we have to thank for our tradition of enjoying fireworks each year on a dark November night. However, if once a year isn't enough, I can thoroughly recommend the Plymouth Firework Championships some of the best firework displays you will ever see.

# 29. A Walk Around Bolt Head

Along all the 630 miles of the South West Coast Path there are countless fine views and beautiful stretches of coastline, which makes it hard to single out individual views, but, in my opinion, one of the finest has to be the views enjoyed while walking around Bolt Head. The rugged beauty of the headland and the azure waters below make it a wonderful place to simply sit and admire the stunning beauty of the South Devon coast.

Walking west along the well signposted Coast Path from Salcombe, you first pass the fine sandy beaches of North Sands and South Sands as you follow the estuary towards the sea. After passing the National Trust property at Overbecks, the path leaves the town and slowly climbs through woodland until you emerge at the entrance to the estuary at Bolt Head, with the turquoise waters of Starehole Bay far below and wide-ranging views eastwards along the coast towards the next headland at Prawle Point.

While sitting and enjoying the natural splendour and tranquillity of the place, spare a moment to remember those for whom these lovely views would be the last they would ever see. Despite being beautiful to look at, the waters around Bolt Head are treacherous and have been responsible for the demise of many ships, and the estuary is home to many shipwrecks and a watery grave for those who sailed them.

Wrecks that have been found around Bolt Head include the remains of a 3,500-year-old Bronze Age trading ship, whose cargo included gold bracelets and tin ingots; evidence of some of the earliest trade in metals with mainland Europe. There are also the remains of a seventeenth-century ship that was loaded with Moroccan gold coins, dating from a time of intense activity by Barbary Pirates, leading to

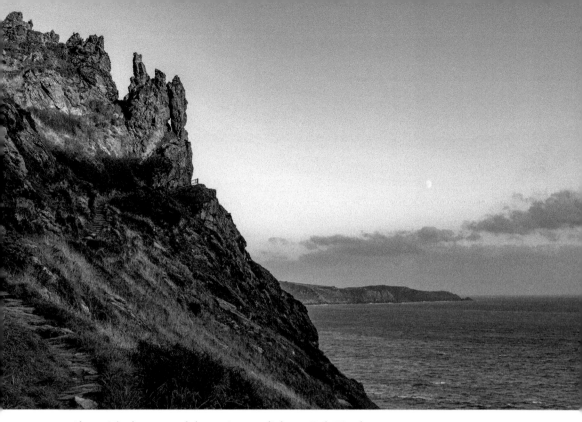

*Above*: The last rays of the setting sun light up Bolt Head.

*Below*: Beautiful Bolt Head with Starehole Bay below.

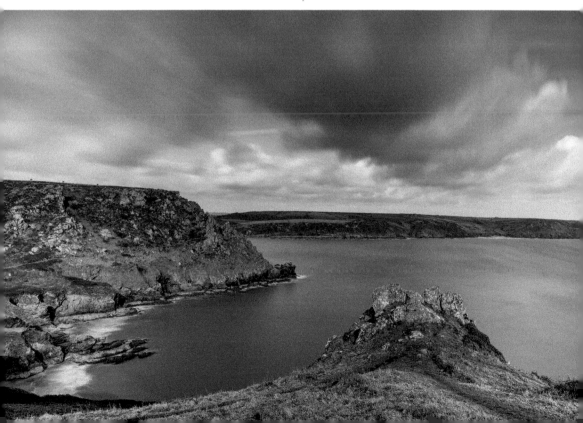

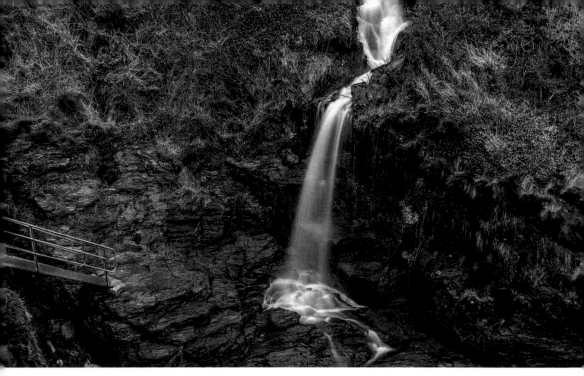

A hidden waterfall below Bolt Head.

speculation that it could have been a pirate ship. From more recent times, there is the wreck of the *Ramillies*, a ninety-gun man-of-war, which left Plymouth in 1760 and sailed straight into a vicious storm. After days of being blown around the seas off Bolt Head, the crew tried to head for home but the ship was smashed to pieces on rocks nearby with all but 26 of the 730-man crew meeting their deaths.

Today the majority of the ships in the area are pleasure boats, which anchor around Bolt Head to enjoy swimming in the clear waters of Starehole Bay. As one of my favourite gems of South Devon, a walk around Bolt Head comes highly recommended.

# 30. Start Point

Unlike the rugged and wild north coast of Devon, much of the south coast is sheltered from the worst of the wild weather as it rolls in from the Atlantic. However, Start Point is an exception. Almost at the southern-most point of Devon and jutting out a mile into the English Channel, the peninsula sees some of the wildest weather and seas along the whole of the south coast of England.

It may well be a wild, wet and windy place, but when the weather is set fine, Start Point is a remote and stunningly beautiful place to be – definitely a gem of South Devon. Whether for a short walk from the nearby car park or a longer walk a little further along the Coast Path, the stretch around Start Point is undoubtedly one of the finest walks in South Devon. It has dramatic cliffs, craggy peaks and breathtaking coastal scenery, topped off by the majestic Start Point Lighthouse perched high above the raging seas.

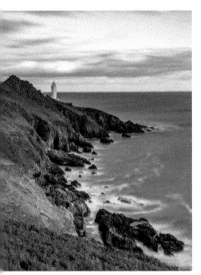
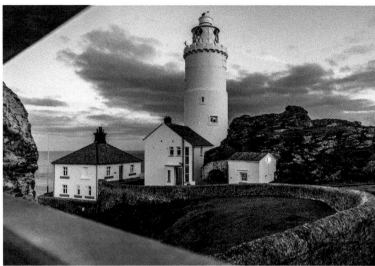

*Above left*: An autumn sunset at Start Point.

*Above right*: Dusk at the Start Point Lighthouse.

*Below*: Stormy clouds over Start Point Lighthouse.

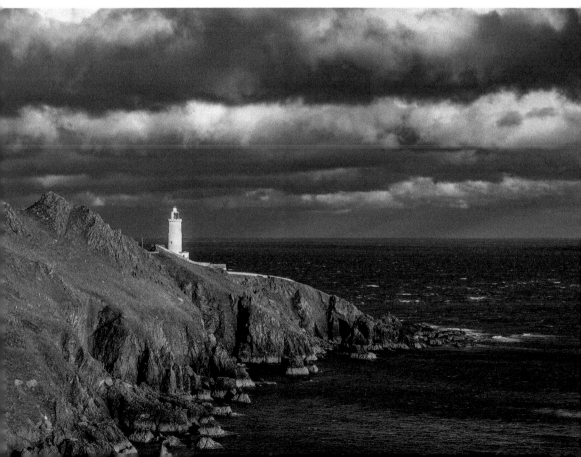

The striking lighthouse was built in 1836 to warn shipping off the treacherous Skerries Bank, and its warning light can be seen up to 25 miles out to sea. Before electrification in 1959, the warning light was provided by oil burners, fuelled by either herring, sperm whale, seal or rape seed oil. In 1862 a fog bell was installed, later being replaced by a more powerful coal-powered fog siren. Two coal-powered engines would force air through trumpets, and the resulting sound could be heard as far away as Salcombe. At one point there were up to three staff looking after the lighthouse and fog siren, all living on site, whose homes are now holiday accommodation. It must be a fantastic place to stay, although perhaps a bit difficult to sleep on a foggy night with the fog siren booming!

The attractive lighthouse is now a Grade II listed building and is open on a number of days throughout the year, when you can take a guided tour to the top of the lighthouse, hear stories about its history and enjoy fine views across Start Bay.

The car park for Start Point is at grid reference SX 82064 37537. Simply walk down the tarmac road to reach the lighthouse.

# 31. Totnes

As a landscape photographer I admit that I am unashamedly biased towards coast and countryside. However, there are some towns that are more than worthy of inclusion on the list and one of those is most definitely the quirky and historic market town of Totnes.

Totnes is a small charming town, situated in the beautiful countryside of the Dart Valley, and has a reputation for welcoming people with alternative lifestyles. This eccentricity gives the town a really nice vibe, and the main street, which climbs up from the river, is full of small independent shops, famed for their promotion of ethical products and very different to many identikit high streets.

Totnes is also a historic town. Situated at the lowest fordable point on the River Dart, it has ancient origins, with evidence of a Roman road linking it to Bath and beyond, suggesting it was well known to the Romans. There were also Saxon fortifications, built to protect the town from Viking raiders in the eleventh century, and many Totnes coins have been found in Scandinavia, reinforcing these links to the town. A fine Norman motte-and-bailey castle, whose ramparts still sit majestically above the town, is one of the best preserved in Britain and was built over the existing Saxon fortifications soon after the Norman Conquest.

The town was one of the wealthiest towns in medieval Devon, with its wealth coming from its position on the Dart where it played a key role in the export of wool and tin from Dartmoor. Its prosperous history can still be seen today in the number of fine historic buildings in the town, with sixty-six properties dating from before 1700 giving snapshots of Tudor, medieval and even Norman Totnes. The most iconic building is probably the East Gate Arch, the original medieval entrance to the town, which still spans the High Street today. There is also the historic Guildhall, built in 1533 on the remains of a Benedictine priory dating back to 1088, which has been the home of the

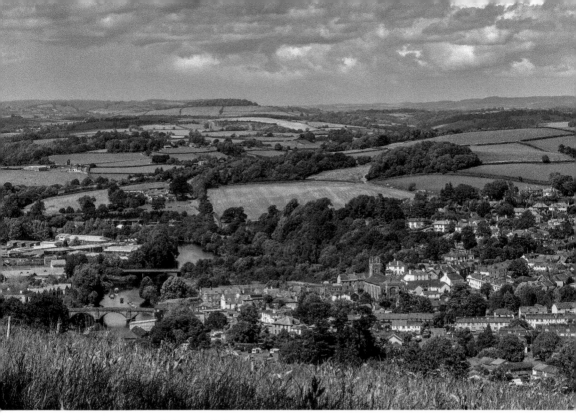

*Above*: Totnes nestled around the River Dart.

*Below*: Totnes Castle sitting high above the town.

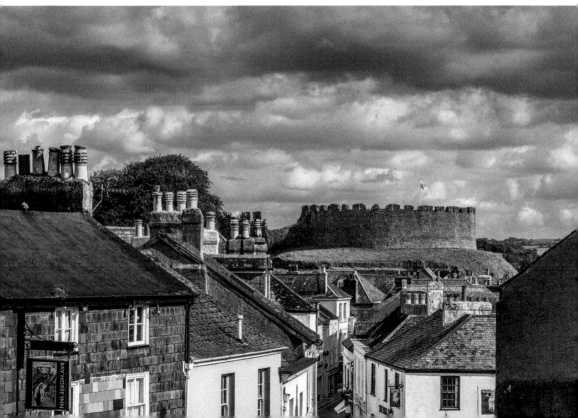

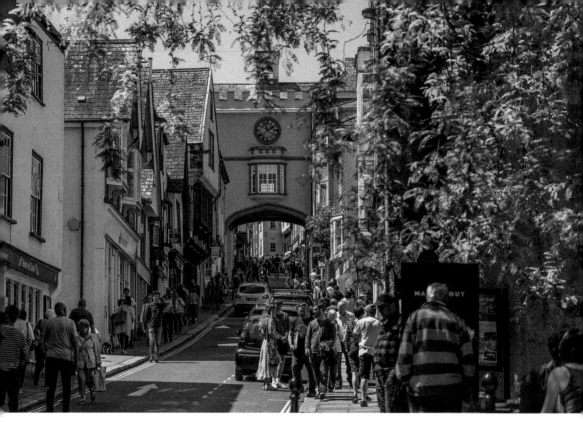

The High Street with Eastgate in the background.

town council for over 450 years. In the historic council chamber are large oak tables where Cromwell and Fairfax sat to plan the closing stages of the English Civil War.

No visit to Totnes is complete without searching out the so-called Brutus stone, which claims to link the origins of the town back to ancient Troy. It is said that Brutus set sail for Britain, which was said to be inhabited by giants. On arriving by ship in Totnes, Brutus is said to have stood on the stone and named the town by proclaiming 'Here I stand and here I rest, and this good town shall be called Totnes'. Although more likely to have been deposited by the last ice age, the Brutus stone can be seen in Fore Street outside No. 51.

# 32. Kents Cavern

There are many limestone caves dotted around the British landscape, but few have such significance to our understanding of the lives of our ancient ancestors as Kent Cavern. As well as giving an insight into early human history, the caves have given up the remains of long extinct animals, including cave bears, who used the caves as shelter over half a million years ago. The caves also provide an insight into some of the amazing geology of Torbay, recognised by the area being recognised as a UNESCO Global Geopark, an award reserved for some of the world's most amazing locations.

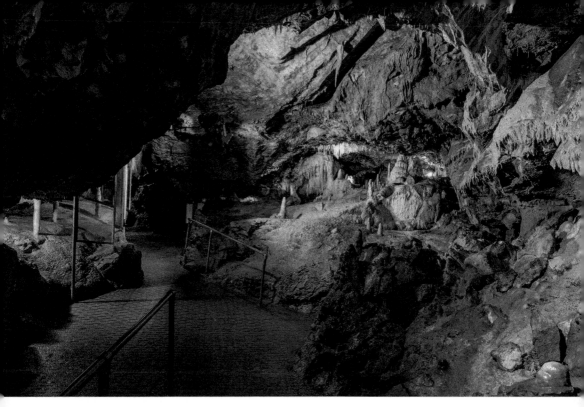

Stalagmites and stalactites adorn the walls of Kents Cavern.

Hidden down a suburban road within Torquay, Kents Cavern once had a reputation as a mysterious place, where sometimes bones were found. The occasional inquisitive visitor would even venture into the labyrinth of caves and inscribe their names on the walls as a record of their visit. It wasn't until the eighteenth century that people began to study the caves and understand just how ancient their contents was, and how important to our understanding of our past.

In the early eighteenth century, antiquarians began to properly explore the caves and started finding bones of long extinct animals alongside man-made flint tools, hinting that they may have used the caves at the same time. This led to the astounding possibility that humans may have been older than the 4004 BC stated by the bible. As this was so against what was commonly believed at the time, the revelations were largely ignored.

By the late eighteenth century, William Pengelly, a Cornishman who had moved to Torquay, began a systematic excavation of the caves, which would last fifteen years. During this time, Pengelly proved beyond any doubt that the bones of extinct animals and man-made tools were laid down at the same time, since they were buried beneath a stalagmite floor that had taken many thousands of years to form. As well as Pengelly's systematic approach laying the foundations for modern archaeology, his work provided indisputable evidence of the true antiquity of humankind.

Despite the extensive work by Pengelly, Kents Cavern still had some secrets waiting to be discovered. One of these was made by Arthur Ogilvy in 1927 when he found a human jawbone still containing teeth in the cave. The jaw was later dated as 41,000–44,000 years old, which remains the earliest fossil of modern humans found in north-west Europe, and makes Kents Cavern the oldest known human settlement in Britain.

# 33. Boringdon Hall

This next gem is somewhere that not only can you visit, but you can also stay the night to soak up the buildings' history while you enjoy five-star hotel luxury, which is exactly how I first stumbled upon Boringdon Hall when trying to find some accommodation in the area some years ago. The name 'Boringdon' is ancient, hailing from Saxon English 'Burth-Y-Don', meaning 'enchanted place on the hill', which I think still sums up well this fine building today.

Boringdon Hall is a sixteenth-century Grade II listed manor house, and its origins date back to medieval times. There was a building recorded on the site in the Domesday records of 1086 and in the twelfth century records show that the priors of Plympton had a 'substantial grange' built on the site. The current Boringdon Hall has recently celebrated its 430th anniversary, that being the date that twenty-four-year-old John Parker and his wife, Frances, completed the remodelling of the medieval building into a fine and fashionable Elizabethan manor house. During the Civil War, Cromwell's Roundheads destroyed part of the house and confiscated it from the Parkers; however, when Charles II was restored to the throne, the house was returned to the staunchly royalist Parker family in 1660, and the house remained in the family for almost the next 300 years. However, by the early twentieth century they had moved on and the house started to fall into serious decline. Thankfully, the ruins of Boringdon were saved in 1984 and, despite a serious fire in the late 1980s,

A grand sweeping driveway leading to the front of Boringdon Hall.

The fine Great Hall with its imposing fireplace.

has been lovingly restored to its former glory and is now one of the finest historic buildings in South Devon.

Boringdon has had some famous visitors over the centuries, including the Elizabethan privateers Sir Francis Drake and Sir Walter Raleigh, who attended a banquet there in 1587. Sitting today in the fine Great Hall, beneath the grand and imposing fireplace (adorned with the coat of arms of James I and the date 1640), the history of the building feels close and tangible.

Boringdon is now a five-star luxury hotel and spa, and if you do decide to stay for a real taste of the building's history, it's worth trying to stay in one of the four-poster rooms in the old part of the house. The hotel can be found on Boringdon Hill just to the north of Plympton.

# Dartmoor

## 34. Scorhill Stone Circle

Britain is littered with prehistoric sites including stone circles, standing stones and henges, which hint at the lives and cultures of the people who inhabited our islands over 2,000 years ago. Although there are many theories for the existence of these ancient monuments: as celestial calendars, to commemorate the dead, or for other ceremonial purposes – we may never know for sure. This only adds to their mystery and a sense of wonder at the huge time and effort expended by our ancient ancestors in building them.

Scorhill Circle bathed in the golden light of sunset.

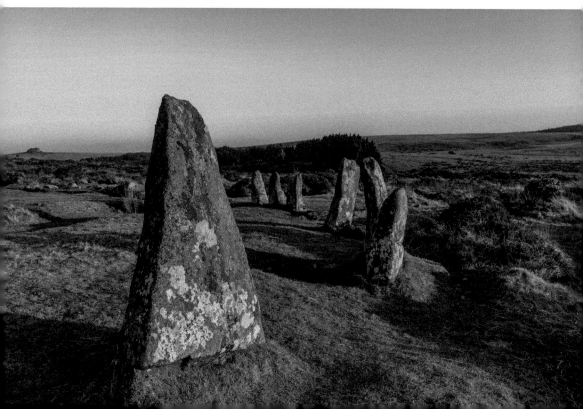

As with many upland areas in Britain, Dartmoor has its fair share of ancient monuments, with fourteen stone circles scattered across its barren moorland landscape, although there are likely to be many more lost in the mists of time. One of the largest, most intact and arguably Devon's finest is the Scorhill (also known as the Gidleigh) Stone Circle, situated on the high moor at Gidleigh Common.

Scorhill Circle was constructed by the people of the Bronze Age, between 2100 BC and 650 BC, and today contains twenty-three standing stones. It is thought that there may have originally been up to sixty standing stones, but, as with many stone circles, many stones have been damaged or even removed over the millennia.

The Scorhill Circle forms parts of the so-called 'Sacred Crescent', a curved line of stone circles on the north east side of the high moor, from Whit Moor Circle in the north to Grey Wethers in the south. The curve of stone circles forms a crescent with around 2 km between each site, suggesting deliberate planning. Although, of course, we will never know the real reason, one suggestion is that the sites marked out the edge of two ancient settlement boundaries, and the circles acted as ceremonial meeting places for those communities.

As with many ancient sites, legends have grown up around the Scorhill Circle. One is that it is home to a fierce ogre who had a passion for sheep, and any which strayed within the stones would be killed and eaten. There are more recent reports of horse riders who say they are unable to get their horses to enter the circle, although as yet there have been no sightings of the ogre.

The Scorhill Circle sits at the bottom of a natural amphitheatre, far away from civilisation (and a mobile signal!) and it's easy to see why our ancient ancestors chose

Sunset behind one of the largest standing stones.

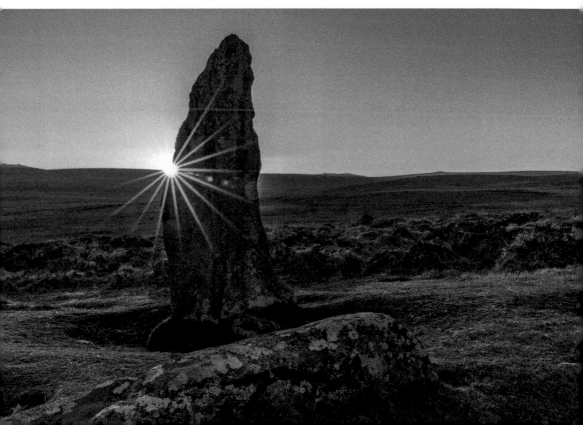

such a beautiful and remote location for a ceremonial site. Although as with all such sites we will never know precisely why it was built, the fact that when looking out from the centre of the circle on midsummer's eve, the sun sets over the tip of the largest standing stone, hints at the wonder of the world around us that may have motivated our ancestors to create such evocative sites.

Scorhill Circle can be found at grid reference SX 65455 87400, a few miles from Gidleigh.

# 35. Brentor Church

One of the most dramatic and picturesque locations in *50 Gems of South Devon* has got to be the tiny medieval church of Brentor, perched on a rocky granite tor on the western edge of Dartmoor. The tor itself is thought to be all that remains of the plug of an ancient volcano, and, standing at 340 metres high, is such a prominent feature in the landscape that it's unsurprising that it's been used for millennia, with obvious earthworks on the slopes of the tor indicating use as a hill fort by our Iron Age ancestors.

There are various folklore tales about how the little church of St Michael de Rupe ('St Michael of the Rock') came into being. My favourite is that of an epic battle

Stunning Dartmoor views around Brentor.

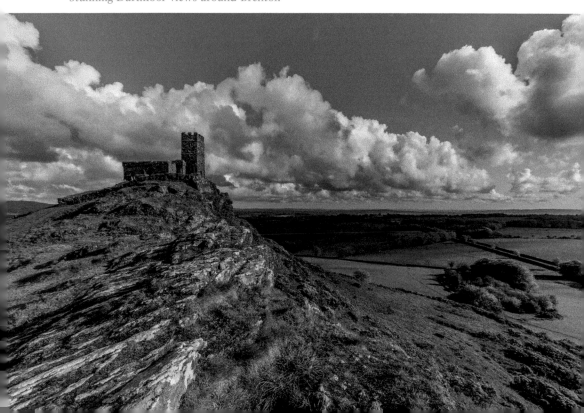

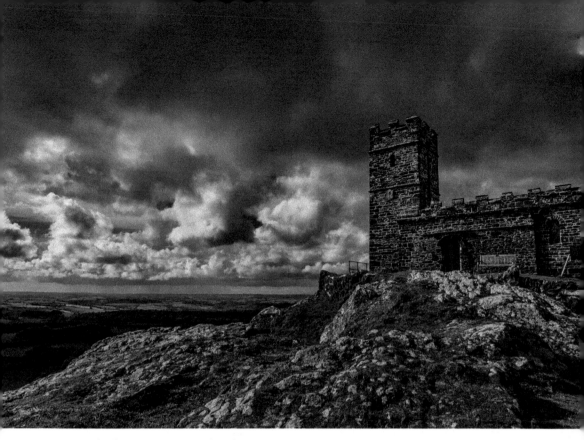

Moody skies over Brentor church.

between a wealthy Devon merchant and the Devil. The merchant was on a ship off the Devon coast when the Devil decided to create an epic storm to try and wreck his ship. In desperation, the merchant prayed to St Michael to save him, and, in return for being saved, vowed to build a church dedicated to him on the first land he saw on their return. St Michael went into battle with the Devil, ultimately coming out of the fight victorious, and in return the merchant built a church dedicated to the saint on the first high ground he saw on their return to port: the iconic hilltop of Brentor.

The church is the highest in Britain, and one of the smallest, and was built around AD 1160 by Robert Giffard, the Lord of Lemerton and Whitchurch. Giffard was indeed a rich merchant, so at least this part of the story of how the church came into being was true.

During a fifteenth-century restoration of the church, a number of skeletons were found buried under the church. What was unusual, however, was that most of them were lying north to south, when the Christian norm is for burials to be oriented west to east (so that they may arise on the Day of Judgement to face God in the east). It's possible, therefore, that these burials were in fact pagan burials, dating from before the Christian church was built.

Despite the steep walk to the top, Brentor is a must for the fabulous panoramic views across Dartmoor to the east and even as far as Bodmin Moor, almost 50 miles to the west. However, on all but the calmest days, be prepared to come back down feeling very windswept!

To visit Brentor church, there is a small carpark adjacent to the tor, half a mile or so from Brentor Village.

# 36. Black-a-Tor Copse

For the ultimate in peace and tranquillity, far away from the hustle and bustle, a visit to Black-a-Tor Copse is a must. Imagine an ancient woodland of stunted oaks, growing among moss-covered boulders, miles from the nearest road and nestled in a quiet valley next to a babbling river – that's what's in store for you if you make the effort to search out this particular gem of South Devon.

The copse is a fabulous example a high-altitude oak woodland, and one of only a handful that can now be found on Dartmoor, and more remote and less well known (and therefore less visited) than nearby Wistmans Wood. Originally called Black-a-tor Beare (from the Anglo-Saxon, 'Bearu', meaning 'wood or grove'), the copse was once much more extensive, stretching from its current location right up the valley and onto what is now open moorland.

The copse sits at 380 metres above sea level and covers 29 acres. Although documentary evidence suggests woodland here in the seventeenth century, it is undoubtably far older. The woodland is primarily made up of common, or English, oak, stunted by their location high up on the exposed moor. The trees are barely higher than 5 metres, with a mass of twisted branches that lean away from the prevailing winds which blast down the valley. Due to the clean air and damp conditions, the woodland is the perfect place for moss and lichens to survive, and is of national importance due to a number of rare species.

Moss-covered boulders beneath the twisted trees of Black-a-Tor Copse.

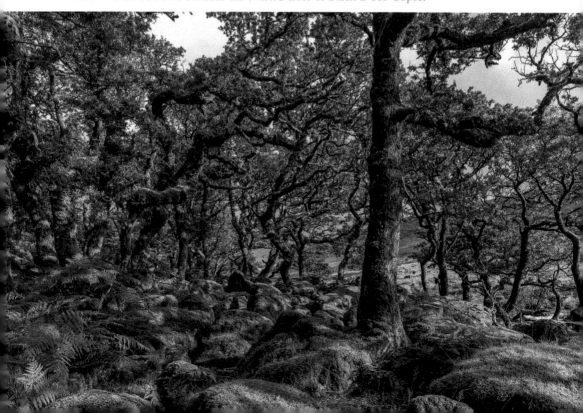

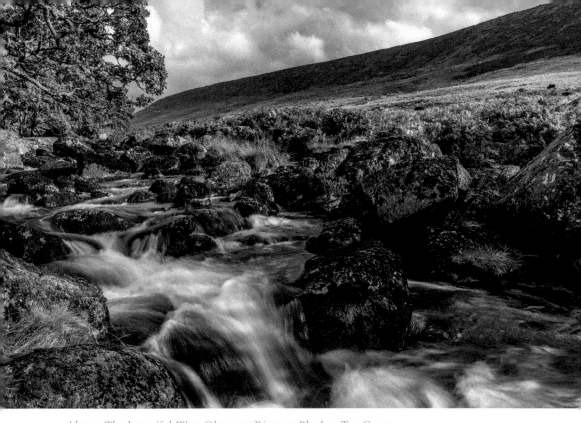

*Above*: The beautiful West Okement River at Black-a-Tor Copse.

*Below*: The nearby tor of Black-a-Tor, which gives its name to the copse.

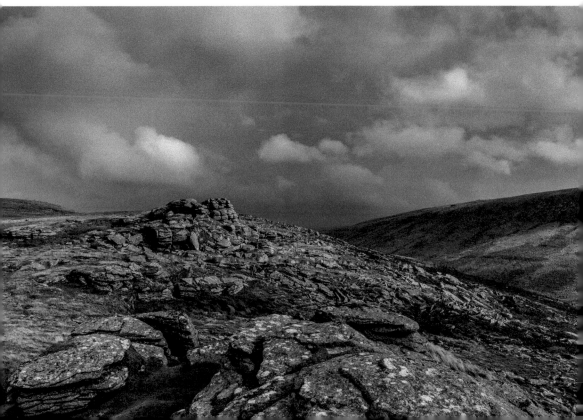

You will need some map reading skills to find this beautiful remote place, at grid reference SX 55824 90220, a mile or so south of the western end of Meldon Reservoir. Be aware that this is a remote and lonely place with no mobile signal and rough muddy paths, so only visit this particular gem if you can read a map and are suitably prepared for whatever the Dartmoor weather might throw at you!

# 37. Meldon Reservoir

There are many reservoirs on Dartmoor, but one of my personal favourites is the Meldon Reservoir, near Okehampton, at the north-west corner of Dartmoor. At 900 feet above sea level, the reservoir and its surroundings are truly magical and provide some of the most breathtaking Dartmoor scenery around. This gem has it all, with the calm waters of the reservoir, surrounded by the steep hills of the high moor, woodlands full of bluebells in the spring, and a beautiful old railway viaduct high above. It's also my go-to location when it snows, as it's one of the only places where it's possible to park just off a main road (the nearby A30, which is normally kept clear of snow), then walk up to the reservoir and from there onto the high moor without risking getting stuck on any snowy Dartmoor roads.

Exposed to the prevailing winds and weather rolling in from the Atlantic, the high ground of Dartmoor has the highest rainfall totals in the South West.

The calm waters of Meldon Reservoir.

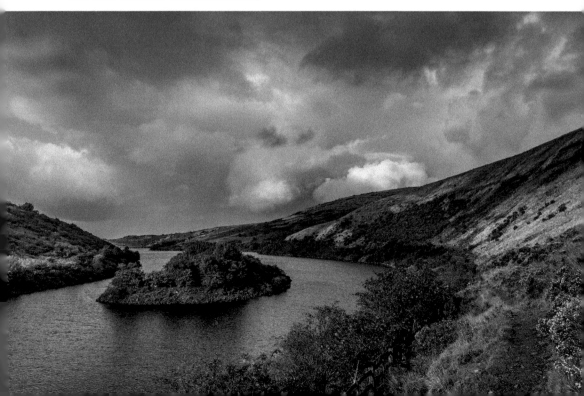

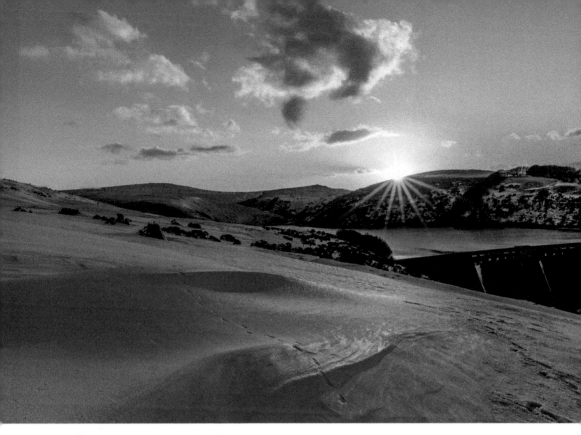

*Above*: A winter sunset over the reservoir.

*Below*: A snowy day at the Meldon Viaduct.

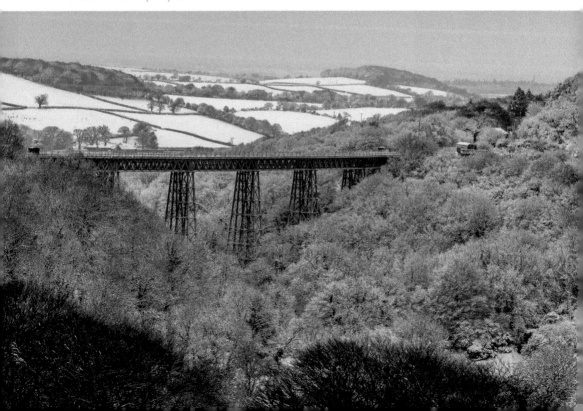

It's no surprise, therefore, that Dartmoor has been providing fresh water to those living in the surrounding area for centuries. In fact, Dartmoor was the location for the first public water delivery system in the country: the 17-mile-long Drake's Leat, which was dug to provide Plymouth residents with fresh water as long ago as 1591. By the mid-nineteenth century, growing populations on the south coast of Devon needed ever-increasing water supplies, so a programme of reservoir building began, with Tottiford Reservoir built in 1861 to supply Torquay and Burrator built to supply Plymouth in 1894.

In 1962, the North Devon Water Board proposed damming the beautiful West Okement valley at Meldon to provide a new reservoir. Having only become a National Park a decade or so earlier, there was stiff opposition to the scheme and the effective drowning of the valley. The opposition was initially effective, but finally in 1970, construction of the Meldon Reservoir went ahead. Although some of the valley was inevitably lost below the water, the area still retains a great deal of its natural beauty.

High above the valley of the River Okement, to the north of the dam, is the fantastic piece of Victorian architecture of the Meldon Viaduct. Built in 1874, the wrought-iron structure took the London & South West Railway across the deep Okement valley on its journey from Exeter to Plymouth. Having only finally closed to rail traffic in the 1990s, the viaduct is now a Scheduled Ancient Monument, and part of the Granite Way, a long-distance cycle route across Dartmoor.

To get to Meldon Reservoir, follow signs from Okehampton to Meldon village. Drive through the village and turn left immediately after going under the railway bridge. After half a mile there is a pay-and-display car park a short distance before the reservoir.

# 38. Lydford Gorge

If you're looking for somewhere to completely immerse yourself in nature then a visit to the National Trust-owned Lydford Gorge, the deepest gorge in the South West, is a must. Located on the western edge of Dartmoor, Lydford is a stunning steep-sided gorge with the spectacular 30-metre-high Whitelady Waterfall at one end and the tumultuous whirlpools of the Devil's Cauldron at the other. Inbetween is a 1.5-mile rugged walk along the beautiful valley of the river Lyd, where the path is narrow, winding and slippery too, so I strongly advise you use the hand rails that are provided to stop you twisting an ankle or falling into the river.

The spectacular Whitelady Waterfall is the longest in Devon and is named after a local legend that the falls are haunted by the spirit of a woman dressed in a long white gown. The falls were formed when the River Lyd cut into the valley of a stream called the Burn. As the Lyd eroded and gradually deepened its valley over tens of thousands of years, a waterfall gradually formed where the stream meets the Lyn Valley.

In the sixteenth century, the gorge was said to be home to a gang of cut throats called the Gubbins, who had a reputation so bloodthirsty that anyone visiting the

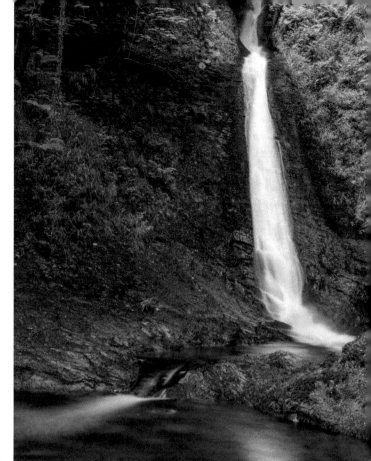

*Right*: The beautiful White Lady Waterfall.

*Below*: A narrow winding path through Lydford Gorge.

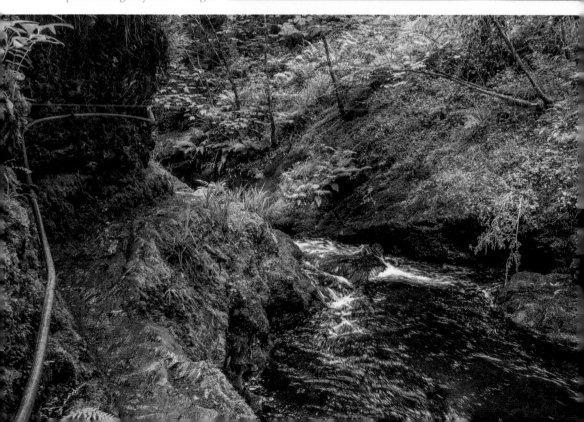

gorge feared for their lives. However, they seem to have moved on by the eighteenth century, when the popular past time of the well-heeled traveller, the European Grand Tour, was in its demise, and the wealthy with lots of leisure time started looking for picturesque places to visit nearer to home. It was at this time that Dartmoor in general, and Lydford Gorge in particular, first became a popular tourist destination.

At the northern end of the gorge is the so-called Devil's Cauldron, a particularly narrow and steep-sided part of the gorge. It's a dark ravine where a narrow viewing platform hovers precariously above the boiling waters to give visitors the full experience. When the river is in full flow the water cascades thunderously down the ravine, deafening and covering in spray anyone standing above – so it's easy to see how the Devil's Cauldron got its name!

Lydford Gorge is a short distance from the village of Lydford, just off the A386 to the west of Dartmoor. Due to the narrow, wet and slippery paths, it's somewhere where you need to be up to the difficult terrain and the approximately 3-mile walk to see all of the gorge. There is at least a café halfway round to stop for some refreshments.

# 39. Hound Tor

Dartmoor is famous for its tors; granite outcrops that are some of the most iconic features of the Dartmoor landscape. There are hundreds of tors scattered over the moors, and each so very different that it's hard to choose favourites; however, one easy choice is the fabulous Hound Tor. It's easy to get to, only a short walk from the nearby car park, always less busy than nearby Haytor, and is a classic rocky outcrop with stunning panoramic views over the Dartmoor landscape.

The tor itself is a splendid pile of weathered granite, arranged in two parallel lines and perfect for a scramble to the top for the fabulous views. There is a local legend that the rocks were hunting hounds, which had been turned to stone after disturbing a witch's ceremony, and it is this that was said to have been the inspiration for the Arthur Conan Doyle classic novel *The Hound of the Baskervilles*. The snack van, parked in the car park below the tor, always makes me laugh, amusingly named *The Hound of the Basket Meals*.

Below the tor are the atmospheric ruins of Hound Tor medieval village, which was home to six households, seven cattle, twenty-eight sheep and eighteen goats at the time of Domesday in 1086. The ruins include a number of Dartmoor longhouses, which would have housed a family at one end and their animals at the other end. In search a harsh landscape, the villagers' animals would have been critical to their survival on the moor – for pulling ploughs, for their milk, their meat and their wool. Although there is evidence that the area of the village was being farmed since Neolithic times, the village did not last for long on this wet and wild part of Devon, and was abandoned by around the turn of the fifteenth century. It's likely that this demise was due to a combination of worsening climate, which led to a number of great famines during the fourteenth century, as well as the terrible Black Death, which wiped out a third of the population of Devon in the mid-fifteenth century.

Hound Tor is a short walk from the car park at grid reference SX 73954 79217.

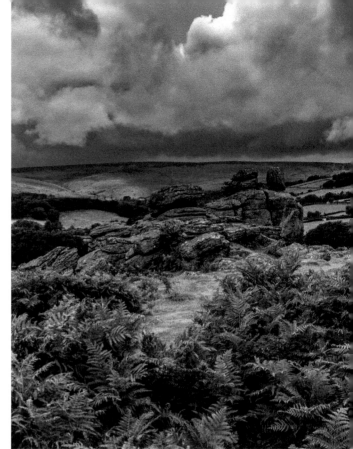

*Right*: Summer storm clouds over Hound Tor.

*Below*: A great place to stop and admire beautiful Dartmoor scenery.

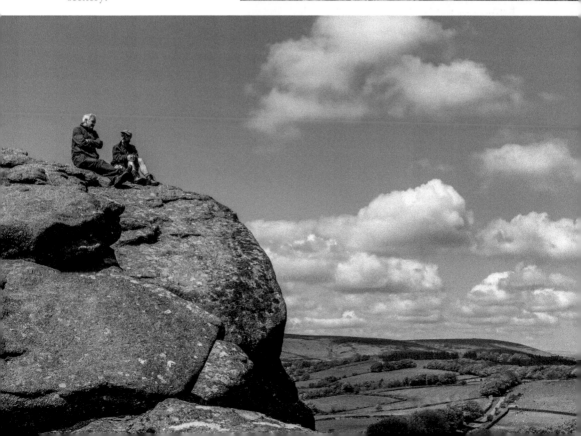

# 40. Emsworthy Mire

For me, a visit to Dartmoor is all about peace and tranquillity, getting away from the crowds and being surrounded by the sights, sounds and smells of nature. Emsworthy Mire definitely delivers this on all fronts.

Situated on the eastern side of the moor, not far from Haytor, Emsworthy is sometimes described as a miniature Dartmoor, since it has a bit of everything that the moor has to offer. It has ruined buildings, the remains of ancient settlements, fields of bluebells, gnarled trees, ancient dry stone walls, wild flower meadows, streams, bogs and an abundance of wildlife.

Now a nature reserve, Emsworthy sits in the valley of the Becka and Snodderbottom (honest!) brooks, yet despite being surrounded by some of Dartmoor's most popular tors, it's very easy to have the whole of the place to yourself with just the sounds of a cuckoo for company (as I did when I took the photo that appears in this section).

This part of the moor is rich in history, starting in the bottom of the valley where there are the ruins of Emsworthy Farm, abandoned in the late nineteenth century. The 'worthy' part of the name suggests very early origins, as it is derived from an Anglo-Saxon word for a homestead or farm.

Just to the west is Hemsworthy Gate, which was an ancient moor gate, used for centuries to stop livestock escaping from the moor. The gate was in place until the Second World War, when the US military removed it as it was too narrow for their vehicles.

A stunning display of bluebells at Emsworthy.

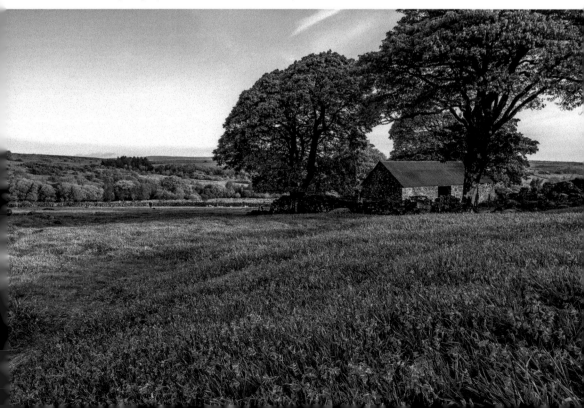

It was later replaced with a cattle grid, which is clearly much more practical on this now busy road.

Further west again and there are the much more ancient remains of Foales Arrishes, one of the most impressive remaining prehistoric settlements on Dartmoor. Despite many stones having been removed to repair roads and walls in less enlightened times, there are still the clear remains of up to eight circular stone huts, the homes of prehistoric farmers who were farming here in the Bronze Age, almost 4,000 years ago.

As a photographer I particularly love Emsworthy for its spectacular display of bluebells in the spring. The display at Emsworthy is a little unusual in that unlike many areas of native bluebells that grow in ancient woodland, those at Emsworthy cover open pastureland, and with the ruins of Emsworthy Farm as a backdrop, create a landscape photographer's dream location! Just be aware that on this high bleak moorland, the bluebells can appear weeks later than those on low ground.

The small car park for Emsworthy is on the B3387, just past Haytor, at grid reference SX 74811 76155. Follow signs to the nature reserve.

# 41. Fingle Bridge

Another exceptionally scenic spot on Dartmoor is the area around Fingle Bridge, near to Drewsteignton and Castle Drogo on the northern part of the moor.

Fingle Bridge itself is a seventeenth-century Grade II* listed granite bridge spanning the River Teign, at the bottom of the steep and wooden valley, and is named after the Fingle Brook, which joins the Teign nearby. The bridge is at an ancient crossing point over the river between two Iron Age hill forts located on hilltops on opposite sides of the river. To the north is Prestonbury Castle, which retains preserved banks and ditches of an ancient high-status fortified enclosure and has fabulous views over the valley. To the south, standing at 337 above sea level, is the similarly ancient Cranbrook Castle, one of four forts in the area that utilised the high ground as easy to defend positions overlooking the valley.

In 1897, a tea stall was founded adjacent to the bridge to take advantage of visitors, which at the time included fishermen, people bringing grain to the nearby Fingle Mill (now a ruin), and even the odd early tourist to this scenic spot. The tea stall was later developed into the more permanent Angler's Rest pub, later renamed to the Fingle Bridge Inn, where today you can still seek refreshment sitting beside the babbling waters of the Teign.

There are a number of stunning walks along the River Teign from Fingle Bridge. One of the best is to follow the path west along the northern side of the river, which climbs through woodland up to Sharp Tor, which has stunning views over the deep wooded gorge below. Above Sharp Tor is the National Trust Grade I listed Castle Drogo, a fine country house built in the early twentieth century and designed by one of our greatest architects, Sir Edwin Lutyens. Lutyens designed many fine country houses, as well as memorials such as London's Cenotaph, and a visit to Drogo is worth it to see what is arguably some of his best work.

Whether for a picnic by the babbling waters of the Teign, a walk to Sharp Tor for the fine views, or a visit to Castle Drogo, Fingle Bridge is worth a visit. Fingle Bridge is signposted down a minor road from Dresteignton, and parking is available along the roadside near to the pub.

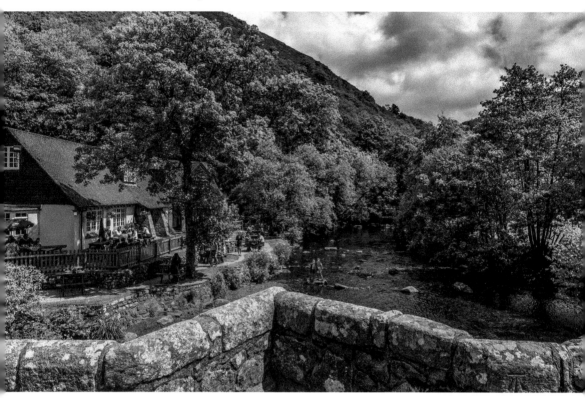

*Above*:  A sunny day at Fingle Bridge.

*Below left*: Autumn colours on the River Teign.

*Below right*: The River Teign in full flow after heavy rain.

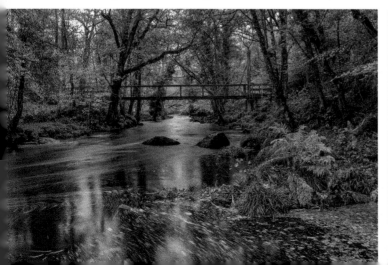
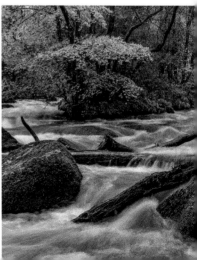

# 42. Venford Falls

This gem is one that's very much off-the-beaten track and not easy to find, but if you enjoy complete solitude, it's one that's definitely worth the effort.

Many of Dartmoor's waterfalls have been commercialised, but what Venford Falls lacks in size (its twin falls are only a few metres high) it more than makes up for in natural beauty. Situated in the south of the moor not far from Holne, the Venford Brook runs from the Venford Reservoir down a deep secluded valley to meet the River Dart. Hidden away in this valley is a beautiful twin waterfall, which tumbles from the glistening waters of the brook, several metres down into a cool pool surrounded by rocks covered in moss and ferns. A beautiful and secluded spot to listen to the sounds of nature.

Well before the reservoir was built to provide water to Paignton in the early twentieth century, our prehistoric ancestors were living in this beautiful part of the moor. Just to the east of the Venford Brook is one of the best-preserved prehistoric field systems on the whole of Dartmoor. Covering 3,000 hectares, there was an elaborate complex of fields, marked by stone banks, which defined different owners' territories during the Bronze Age (from 2000 to 700 BC). As well as evidence of the farming practices of our ancestors, there are also the remnants of the homes where they lived, with the remains of up to ten hut circles sitting high on the hillside above the Venford Brook. Although life would have been hard on this high moorland, it must have been wonderful to have looked out of the doorway of their homes upon such stunning natural moorland beauty.

To get to the falls, park in the small car park to the north-west of Venford Reservoir at grid reference SX 68541 71258. Take the path that runs parallel to the woodland at the back of the car park. Follow this parallel to the valley of the Venford Brook for around half a mile, then head steeply downhill to the brook. The falls are approximately at grid reference SX 68846 71661.

*Below left*: The beautiful and remote Venford Falls.

*Below right*: The twin waterfalls flow over moss-covered rocks.

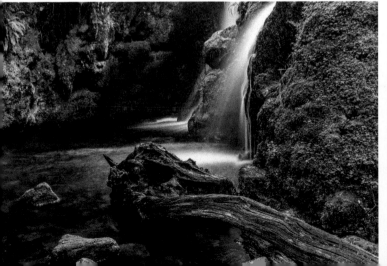
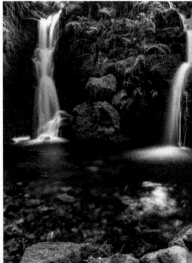

# 43. The View from Bench Tor

A short distance from Venford Reservoir is what has to be one of the best views in the whole of Dartmoor: the panoramic views over the beautiful Dart Valley from Bench Tor.

Parking in the car park to the east of reservoir, follow the path approximately north-east (staying parallel to the line of the valley to your left) and after around half a mile you will reach a line of rocky peaks that mark the edge of the plateau, high above the Dart gorge at grid reference SX 69153 71630. From there you get fantastic views of the wooded valley of the Dart, cutting west to east below you, and the rocky crags of Sharp Tor and Mel Tor on the other side of the valley.

The River Dart is Dartmoor's longest and most iconic rivers, even lending itself to the name of Dartmoor itself. First recorded as the River Derte in 1162, the name is Celtic and thought to mean 'river where oak trees grow', which is very apt as you look down on the wooded valley today.

The Dart is formed from two main rivers – the West Dart and East Dart – which each begin life on different parts of the high moor, merging at Dartmeet before leaving the moor and heading via Buckfastleigh to meeting the coast at Dartmouth.

The Dart is the only Dartmoor river with a folklore legend attached to it. The legend goes that once a year, the river demands a life, and when it's ready for its

Stunning Dartmoor views from Bench Tor.

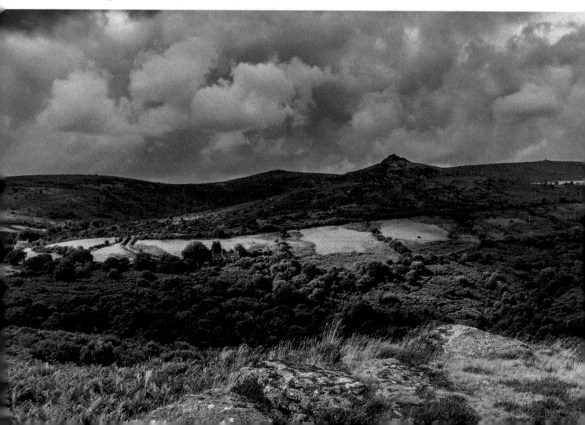

annual victim it will cry out to summon a victim. It is said that if you sit on Bench Tor when there is a north-west wind blowing, that the wind causes a booming sound in the gorge below, and this may well have led to the legend.

As well as lending its name to places along its course such as Dartmouth and Dartington, the legend of Brutus sailing up the Dart to Totnes means that the river even has a role in the naming of Britain. The legend goes that Brutus came ashore and as well as naming Totnes, he proclaimed that the island on which he stood would be called Britain.

The Dart is an iconic and beautiful Dartmoor river, with many fine views along its length, but few finer than the view from the top of Bench Tor; a view that's most definitely a gem of South Devon.

# 44. Leather Tor and Sharpitor

There doesn't appear to be a definitive list of Dartmoor tors, but a quick search suggests there are well over 400. Tors were formed by the weathering of the granite of Dartmoor, over the vast space of time (more than 280 million years) since the rocks were first formed. With so many tors, it's really hard to single out just a few favourites, but the twin tors of Leather Tor and Sharpitor were easy to choose, as they are easy to get to, yet within five minutes you can feel that wonderful Dartmoor isolation, as well as enjoy stunning moorland views.

Mackerel skies above Leather Tor with Sharpitor behind.

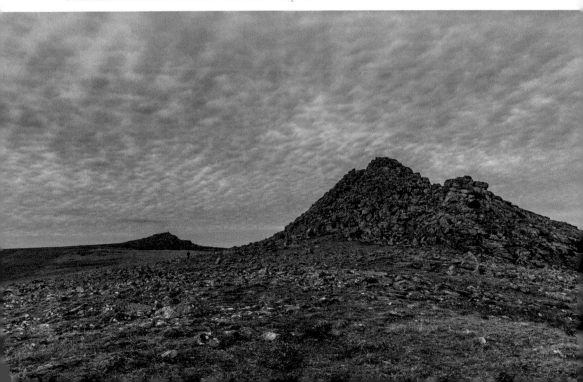

*Above*: Leather Tor sitting among beautiful Dartmoor scenery.

*Below*: A gorgeous winter sunset below Sharpitor.

Starting at an unmarked car park on the B3212 Yelverton to Princetown road at grid reference SX 55708 70683, Sharpitor sits directly above and just a short walk to the south-east from the car park. From the top of Sharpitor there are panoramic views of the edge of Dartmoor to the west, Walkhampton Common to the north and Burrator Reservoir to the south. A short walk to the south-west, on slightly lower ground, is the steep fin of granite of Leather Tor. It's quite a scramble to the top of the tor, but worth the effort for fine views over Burrator and the south moor.

The area might seem wild and remote and home to just sheep and Dartmoor ponies today, but as with much of Dartmoor, it was not always so. To the west of Sharpitor, near Peek Hill, are the remains of a Cold War bunker, one of a network of observation posts set up across the UK between 1955 and 1991. Their job was primarily to warn the general public of a possible nuclear attack and take observations that would have helped with forecasting the track and intensity of any nuclear fallout. It was thought that the nearby naval base at Plymouth would likely be a prime target in the event of any nuclear attack. The observation post was decommissioned in 1993 after the fall of the Soviet Union, and all that can be seen today is the entrance to the concrete bunker.

Today the area around Leather Tor and Sharpitor is peaceful once more, and an easy place to lose yourself in the tranquillity and beauty of the Dartmoor landscape.

# 45. Widecombe-in-the-Moor

There are so many quaint and beautiful villages scattered across South Devon. However, one of the best views of any must be on the approach to Widdicombe-in-the-Moor from Haytor, which, to me, is a view that simply sums up Devon.

Nestled in the bottom of a beautiful Dartmoor valley, surrounded by high rocky tors, Widecombe (as it's usually known) quite rightly attracts large numbers of visitors in the summer months for its picture-postcard looks. The village is probably best known for its annual fair, which has been going for 150 years and was made famous by the old folk song called 'Widecombe Fair'. The song tells the story of a trip to the fair by some local characters (including 'Uncle Tom Cobley and All'), and the fate of the borrowed grey mare of Tom Pearce, which dies on the way home from the fair after seven of the revellers have a few too many drinks and all climb on its back for a ride home. The granite village sign on the way into the village depicts this famous scene, with seven men on a horse.

Widecombe has everything you would expect from a picture-postcard Dartmoor village. It has a village green where wild Dartmoor ponies sometimes wander, next to which is a grand medieval church nicknamed The Cathedral of the Moors and a fifteenth-century oak-beamed pub. There is also the obligatory scattering of tearooms to keep the summer visitors fed and watered.

On the outskirts of the village is the so-called 'Saxon Well'. Although its history is lost in the mists of time, its name suggests it's very old. It's also the source of a

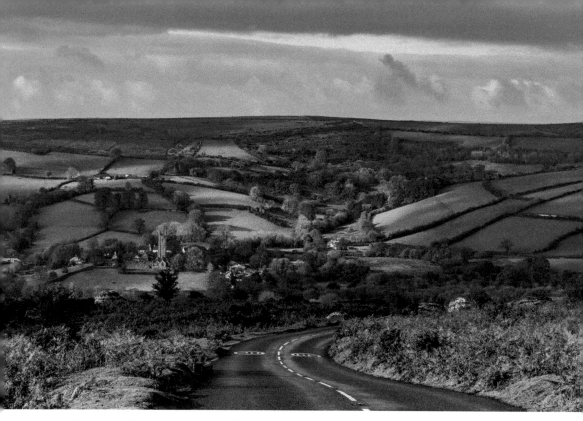

*Above*: On the road to Widecombe.

*Below*: Widecombe church.

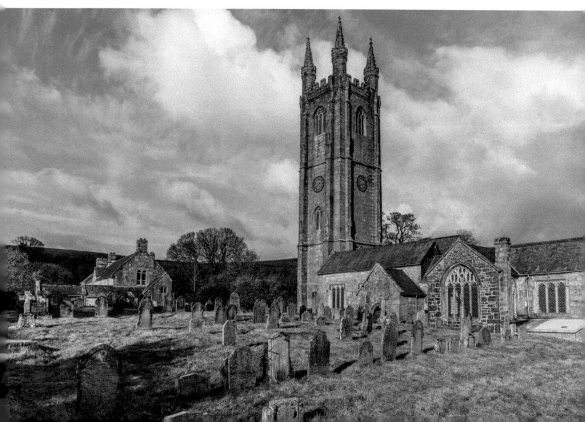

local legend that says that the Devil stopped to drink from the well in 1638, but that because the water caused his throat to sizzle, he lashed out and hurled a ball of fire at the nearby church. Many folklore tales are loosely based on real events, but this one can be traced directly to a tragic event that hit St Pancras Church in that same year, when lightning hit the tower and debris fell on the nave below, killing four people and injuring sixty others.

Widecombe is easy to find a few miles west on the B3387 from Haytor, but don't forget to stop at the top of the hill to take in the fantastic views of the village nestled in the valley far below.

# 46. Foggintor Quarry

It may just be a man-made hole in the ground, but Foggintor Quarry is a very special and beautiful gem of South Devon, and also provides an insight into Dartmoor as a place of industry long before it was a place of leisure.

Originally there was a rocky outcrop called Foggin Tor, on a desolate part of the South Western moor, but around 1820 it became one of three great granite quarries of Dartmoor (the others being Merrivale and Haytor), where granite would be quarried for the next hundred years. The granite mined on Dartmoor was considered to be very fine and was used extensively across the country including in some of London's iconic landmarks such as London Bridge and Nelson's Column.

In its heyday during the 1840s, Foggintor Quarry was a major operation, with a community of more than 300 people, including blacksmiths, stonemasons and labourers, and there was a large complex of buildings to support them including stables, a smithy and even a chapel. In 1833 more than 8,000 tons of stone were quarried and removed by horse-drawn carts, and one gunpowder explosion produced a single granite block that weighed more than 1,000 tons.

The mine closed in 1938, and over the next eighty years, nature started to reclaim what was once a busy industrial landscape. The main quarry is now a still deep pool of crystal-clear water, surrounded by tall granite cliffs, which echo to the sound of birdsong. The surrounding landscape is barren, windswept, and scattered with boulders from its industrial past, and despite being only a few miles from Tavistock it, gives an impression of true remoteness.

Despite its industrial past, Foggintor is a place that is stunningly beautiful in the sunshine, with fantastic views over barren moorland dotted with sheep, and is brooding and moody in bad weather when the fog rolls in – definitely worth searching out.

To find Foggintor, park in the small rough roadside car park on the B3357 at grid reference SX 56732 74981, and walk down the adjacent track where you will find the quarry after around a mile. Do remember though that it's an unmanaged wild landscape with sheer drops and deep water, so please take care if you visit this special place.

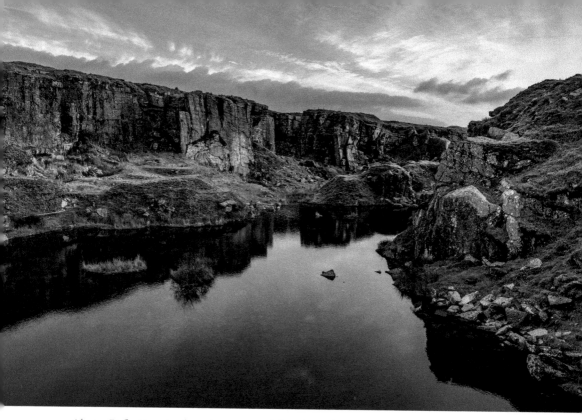

*Above*: Reflections in the calm waters of Foggintor Quarry.

*Below*: Sunset over Foggintor ruins.

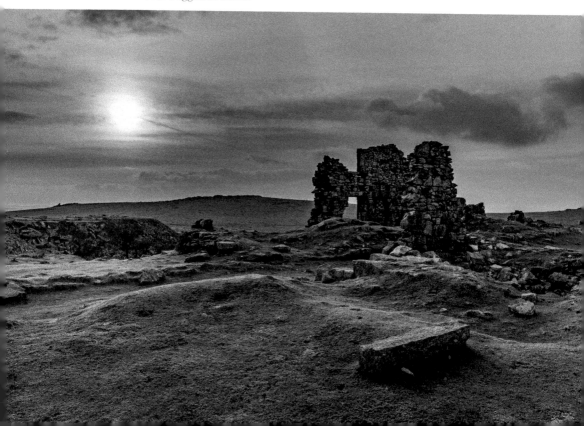

# 47. The Warren House Inn

Being rather partial to the odd pint of Devon cider, I couldn't complete a list of South Devon gems without including a pub. As I'm also rather partial to remote and beautiful places, the Warren House Inn immediately became the obvious choice. As well as being the highest pub in Devon (at 434 metres) it is also one of the most remote; located in the middle of Dartmoor, it is one of only a handful of buildings scattered across this part of the wild and exposed high moor.

Located on the road between Postbridge and Mortenhampsted, there has been a pub on the site (originally on the other side of the road and called the Newhouse Inn) since around 1760, serving passing travellers and miners from nearby tin mines. In 1845 a new pub was built, and this is the building that remains today, although later renamed the Warren House Inn, after the many rabbit warrens nearby, which are likely to have provided the staple diet of the local tin miners.

According to local folklore, a peat fire was lit in the new pub hearth using embers from a fire at the original pub, and this fire is said to have burned continuously ever since. If you were working or travelling on the inhospitable high moor in years gone by, it must have been a welcome thought that there was always a roaring fire to warm yourself at the inn!

Being on the high moor, the Warren House Inn sees more than its fair share of extreme weather and has often been cut off by snow. The worst snowstorm in over

Warren House Inn sitting alone in the Dartmoor landscape.

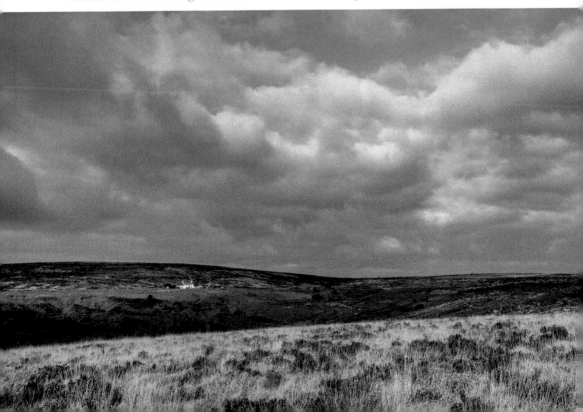

A lone car passes the inn beneath the colourful skies of a winter sunset.

200 years was during the winter of 1962/63 when a blizzard hit the West Country on Boxing Day 1962, leaving snow drifts up to 20 feet high. The snow continued to fall during January and February, so that despite the odd temporary thaw, the pub was cut off from the outside world until March 1963! During that memorable winter, 1,300 sheep, ponies and cattle had to be dug out of snowdrifts, and the pub, as well as many Dartmoor villages, only survived by having supplies dropped by helicopter.

The traditional Warren House Inn, with its oak beams and open fires, is definitely worth a visit, and it's also a great base to explore the beautiful nearby moorland. In the valley below the pub is the remains of Vitifer Tin Mine, which is now being slowly reclaimed by nature, and to the east is Grimspound, the best preserved and largest Neolithic settlement on Dartmoor.

Despite the remote location, the pub is easy to find; simply drive along the B3212 from Postbridge towards Mortenhampstead and you can't miss it.

# Inland Devon

## 48. The Grand Western Canal

A gem of South Devon that is all too easy to drive past without even knowing it's there (something I did for years before finally stopping to visit) is the peaceful and scenic Grand Western Canal near Tiverton (sometimes referred to as the Tiverton Canal).

The canal meanders for 11 miles through beautiful rolling Devon countryside from Tiverton to Lowdwells, near the border with Somerset. It began life over 200 years

The Tiverton Canal at Ayshford Chapel.

ago as part of a grand plan to connect the Bristol Channel with the English Channel by building an inland waterway to join the Exeter Canal to the Bridgewater and Taunton Canal. The first section was built between Lowdwells to Tiverton, which was completed in 1814 at a cost of £244,500 (the equivalent of over £11 million today). It was an engineering masterpiece by the engineer John Rennie, as despite the rolling countryside, the canal is completely level throughout its length from Tiverton to Lowdwells without the need for locks or boat lifts. During its heyday, the canal was busy with boats transporting limestone from quarries near Holcombe Regis to Tiverton, as well as coal from Tiverton to Taunton. Many of the original features of the canal can still be seen today, including the remains of limekilns near the Waydown tunnel, and a fine aqueduct at Halberton, which was based on a design by the leading Victorian engineer Isambard Kingdom Brunel. Today you can still see the remains of the railway line beneath, where Brunel's steam trains used to thunder through on their way to Exeter.

In 1830, the section from Lowdwells to Taunton was completed. However, by this time the amount of traffic using the canal was insufficient to justify the extension down to Exeter and so this was never built. The section from Lowdwells to Taunton was closed in 1868 and was later drained, but the original 11-mile section is still navigable today and used by leisure boats, as well as a horse-drawn barge, which takes visitors on tours of the canal during the summer months.

The canal is now a country park and nature reserve and the perfect spot for a peaceful easy stroll, or an afternoon cycle ride alongside the calm waters. There are stunning views of the beautiful rolling Devon countryside, and an abundance of wildlife, including herons, otters and dragonflies for whom the quiet canal makes the perfect home.

Flat paths alongside the canal make for easy walking.

# 49. Coldharbour Mill

The next gem is something a bit more industrial: Coldharbour Mill, one of the oldest remaining and best-preserved woollen mills in the UK. The mill provides a fascinating insight into one of Britain's most important medieval industries, when Exeter was at the centre of the woollen trade.

There had been mills beside the waters of the River Culm since Saxon times, with the Domesday Book recording two mills in the area in 1086. Some land and a grist mill (for grinding grain) was later bought by Thomas Fox in 1797 in order to develop a woollen mill. Amazingly, Fox Brothers Co., which originates from that venture, is still manufacturing woollen goods on a small scale in nearby Wellington today.

At its peak, the company employed around 5,000 people and owned nine mills. Various different woollen products were made throughout the mills' history, including flannel (which was developed and patented by Thomas Fox), and vast numbers of puttees (leg bandages) were manufactured to help protect First World War soldiers from the horrific conditions in the trenches. In the early days of the mill, Devon roads were extremely poor and a delivery by cart to London could take more than a week.

Coldharbour Mill is unusual in having operated using both the original water power (via a water wheel that dates back to 1822) and steam power right up to the time of the closure of the mill as a business in 1981.

The old mill buildings.

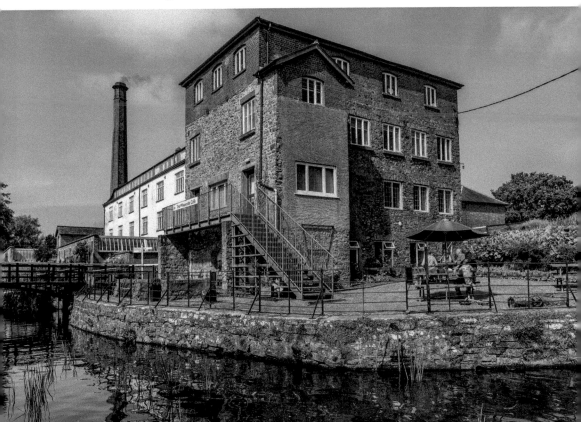

The boilers in full flame for steam day at Coldharbour Mill.

Today, Coldharbour Mill is a working museum, allowing visitors to see much of the machinery that was in use throughout the nineteenth and twentieth century. On steam days, the huge boilers are fired up with coal by volunteers dressed as traditional mill workers, and the machinery once again bursts into life. Visitors can relive the sights and sounds of a Victorian mill, and see demonstrations of textiles and rugs being made in the traditional way.

Historic England describes Coldharbour Mill as 'one of the best-preserved textile mill complexes in the country' and it's definitely worth a visit for a sense of Devon's industrial past. The mill is generally open during the summer from Easter onwards, and also opens for a number of steam days throughout the year, including New Years' Day. The mill can be found in the village of Uffculme, around 3 miles south-east from junction 27 of the M5.

# 50. The View from Culmstock Beacon

The Blackdown Hills is an Area of Outstanding Natural Beauty, north-east of Honiton and on the border between Devon and Somerset. It's an area with steep river valleys, and a patchwork of fields dotted with farms and small villages. The Blackdown Hills have many fine viewpoints, but one of the best is from Culmstock

Sunrise at Culmstock Beacon.

Beacon, which sits at 250 metres above sea level on the edge of the high plateau and has panoramic views down to the valleys of the rivers Culm and Exe far below.

As well as fine views from Culmstock Beacon, the location of the beacon is visible from miles around, which probably explains why there has been a fire beacon on this spot for many centuries. The current beacon building is a small round beehive-shaped stone hut, and is one of a chain of beacons (of which only two now survive in Devon) built to warn of advancing enemies. Although it has been rebuilt, the structure dates from Tudor England of the early 1500s, and it undoubtably played a role in sending the alarm when the Spanish Armada was sighted off the south coast of England in 1588.

The windows are on opposite sides of the building and are aligned with the locations of the next beacons in the chain, at Upottery and Holcombe Rogus. The beacon would have been manned by a team of trustworthy villagers from nearby, taking in turns to sit and watch for fires being lit at nearby beacons, before quickly lighting a fire to pass the alert up the chain to London. Records show that Spanish sailors reported seeing fires on hilltops as soon as they came in sight of the English coast, showing just how effective the system was in practice.

The area around Culmstock Beacon is fabulous for a walk, or a picnic, or just to take in the spectacular views. The beacon is at grid reference ST 11001 15070 and various footpaths and bridleways head from nearby Culmstock up onto the plateau.

# About the Author

Originally from Gloucestershire, Gary spent more than two decades living in the south-east of England, many miles from the nearest coast, before making Devon his home in 2003. After several years of telling friends and family how wonderful it was living in Devon, he eventually realised that, although he said it a lot, he very rarely actually got out to explore his new home! All of that changed in 2007 when he first walked the spectacular South West Coast Path. This began a journey of exploration that saw him fall in love with Devon, walk the Coast Path twice, and develop a passion for photography, leading to him eventually become a professional photographer.

Today, Gary is a professional photographer and Devon specialist, and makes his living from travelling around Devon with his camera. Although he feels he's still only scratched the surface in finding all of the amazing spots that Devon has to offer, in *50 Gems of South Devon* he shares with you just some of the beautiful places, fabulous walks, stunning views and amazing events that South Devon has to offer. He hopes this helps the reader to start to explore the amazing place that he is proud to call home.